Sacha

Born This Way

Friends, Colleagues, and Coworkers
Recall Gia Carangi, the Supermodel
Who Defined an Era

"If you obey all the rules, you miss all the fun."

— Katharine Hepburn

CONTENTS

LEGAL DISCLAIMER

The interview subjects quoted in this book gave explicit permission for their comments, recollections, and observations to be used, at the author's discretion, in any way that did not materially falsify or distort their words or their intentions. With the exception of a few interviews conducted by email, the majority of the interviews in this book were recorded and then transcribed, and every attempt has been made to represent the subjects' thoughts and opinions faithfully and accurately. In the interests of readability, interviews may have been paraphrased, abridged, edited for clarity or coherence, or quoted only in relevant part. Some names and identifying details have been changed to protect the privacy of sources or of third parties. Unless otherwise stated, the views expressed in the interviews represent the subjects' personal perspectives and do not necessarily reflect the views of the author, nor does the author make any claim about their validity or objective accuracy.

ACKNOWLEDGMENTS

My heartfelt thanks go to Giovanni Giglio for the interview with Sasha Borodulin, which put everything else into motion. Similarly, I am grateful to Gregg for interviews with Robin Osler, Christiaan Houtenbos, and Albert Watson, and to Gianmaria for the interview with Nicholas Prins. I owe an enormous debt of gratitude to the wonderful Fausto Callegarini, "the" interpreter and much more. His profound knowledge of American show business and his charm ensured that access to important sources did not remain a mere fantasy. With professionalism, dedication, and humor, Fausto spent countless hours on this project, carrying out the lion's share of the interviews and transcribing them, all of which made it possible for this text to come together. Matteo Giuliani edited my prose with consummate care, and his contributions were illuminating creatively, stylistically, and personally. From the bottom of my heart, I thank all the interview subjects, from the first to the last. Your kindness and helpfulness allowed me to come face-to-face with an unknown Gia. I know that recalling the time you spent with Gia was a complex and, at times, emotionally draining experience, even as it was also great fun and, as some of you mentioned, even cathartic. I am deeply grateful to you for having come with me on this journey. Profound thanks go to my interview subjects, who appear here in the order in which they were interviewed: Alexander Borodulin, Robin Elmslie Osler, Renato Grignaschi, Christiaan Houtenbos, Michael Doster, David Radin, Albert Watson, Jimmy Destri, Jeffrey Alan Cella, Stan Malinowski, Richard Warren, Robert Menna, Isabel Russinova, Alessandro Stepanoff, Sam Scott Schiavo, Wendy Whitelaw, Matthew Rich, Angelica Novaes, Edward Tricomi, Harie von Wijnberge, Chuck Zuretti, Lisa Jouet, Sergio Valente, Glenna Franklin, Jason Savas, Richard Boch, Steve Sleppin, Andrew Brucker, Garren, Nicholas Prins, Alan Kleinberg, Anthony DeMay, Stephen Prezant, Joey Mills, Bill Curry, Eva Voorhees,

Lane Pederson, Shelley Promisel, Kim Charlton, Joseph Petrellis, Bradley Burlingame, Suzanne Rodier, Frankie Sestito, Rob Fay, Eric Boman, Juli Foster, Lisa Ryall, Maury Hopson, Patty Sicular, Barbara Paladino, Sondra Scerca, Michael Stevens, Gad Cohen, and Michael Holder. I would add Norma Stevens and Francis Rick Gillette to this list. Without their advice, I would have lost the chance to include two terrific interviews in this book. Thank you, Matt Pollock, for the invaluable help you provided me from Los Angeles. Last but not least, I am grateful to the members of my family for their support over the years and for helping me weather the difficult moments that occurred along the way to bringing *Born This Way* to life.

AUTHOR'S NOTE

Born This Way was conceived with a specific purpose in mind: to make reliable, first-hand recollections of Gia Carangi available to a wide public and, by so doing, to document just how special Gia was—as a human being and as a professional model. As I rifled around among memories that had been sealed away for decades, priceless gems came to light, illuminating and giving new brilliance to Gia's image.

The idea for this book began in a personal conviction, a sensation that emerged after painstaking research and extensive interviews: There was much more light than shadow in Gia's short life. The shadows, unfortunately—however few they may have been—threaten to tarnish the memory of a young woman who, leaving her physical beauty aside, was also magnificently talented. Through the words of her friends, colleagues, and acquaintances, my hope was highlight Gia's joyous, affirmative qualities.

Obviously, however, I had neither the desire (nor the ability) to cancel out the full reality of Gia's life, meaning specifically her troubling drug addiction. Many of the voices that appear in this book recount how the young model found herself caught in a vicious circle—and they recall the efforts to help of those around her. Putting these matters in black and white now also means speaking frankly about the realities of the times in which Gia lived—convinced, as I am, that Gia was the victim of a culture that could not hear her cries for help but which was nonetheless eager to manufacture webs of gossip and rumor around her. Some of those stories, though they may have contained a grain of truth, became the basis for implausible accounts that served only to inflate the sensationalistic aspects of Gia's life and sully her memory.

Given the kind of book I had in mind—not precisely a biography, in part because it is concerned with such a limited span of time in Gia Carangi's life—I chose to structure substantially

"open" interview questions in order to allow my subjects greater freedom to respond. In some cases, their memories emerged in blocks that were very nearly ready-made chapters. In other cases, their recollections required more shaping. I asked subjects a variable number of questions (based on how well they had known Gia) that were generally focused on a limited number of topics, intending, by so doing, to give the reader the opportunity to draw his or her conclusions from the various accounts.

In some cases, interview subjects balked at the way a question was phrased. In an attempt to get to the truth of the matter, I had, in fact, chosen to be deliberately provocative in dealing with the most controversial topics, so such a response was hardly surprising. These exchanges did, however, unexpectedly create the ideal conditions under which interesting and highly personal observations could emerge as alternatives to common perceptions. These perspectives represented untraveled paths, and they led to aspects of Gia's character that would otherwise have remained unknown.

While there was sometimes a clear convergence of opinion and memory among interview subjects, in other cases there was an obvious clash of views. Such differences of opinion or recollection shouldn't be taken as logical inconsistencies or as evidence of Gia's capricious character. Rather, they lead us toward a deeper understanding.

When we visit a museum and find ourselves before a painting that at first seems difficult to understand, we're tempted to move backwards and forwards, to examine the image from different angles. The same is true as we position ourselves in an attempt to understand the world that Gia inhabited. An overall perspective becomes possible only when we consider a range of vantage points. In the case of sensitive issues whose objective reality we cannot know (and given Gia's inability to speak for herself), such varying points of view are not meant to represent absolute truth. Rather, they are perceptions and, as such, leave room for debate.

In compiling a list of the people I wanted to interview, I

leaned toward those who had never before commented on Gia in any public forum. My intention was to bring together never-before-heard perspectives on Gia's life and modeling career. There are a few exceptions, of course, and they help balance out the accounts that appear here. Just as in a courtroom, where what witnesses say on the stand must be reconciled with the facts in order to bring an ultimate truth to light, the literary truth of a book like this one consists of the validity of the interview subjects' accounts.

As a result, I kept two fundamental criteria in mind in my effort to keep this book as close as possible to that literary truth: the consistency of what interview subjects told me and the reliability of their "testimony." In many cases, demonstrating commendable intellectual honesty and respect for Gia's memory, subjects chose not to answer specific questions in order to avoid adding weight to hearsay and rumor. Overall, I chose to favor subjects' memories, emotions, sensations, and personal experiences over dry chronological accounts, which, given the amount of time that has passed since these events and relationships took place, the lack of archival sources, and so forth, would have nonetheless been impossible to confirm in every detail.

Sacha Lanvin Baumann

FOREWORD

Legendary hairstylist Maury Hopson knew what Gia Carangi was: a true star. "Her essence very much embodied [that of] late film actor and 'rebel,' James Dean," Hopson says. "Her depth of character and unique vulnerability were very similar, to my mind. Had Gia lived longer and perhaps, made movies, she would have had a far-reaching impact, much like [Dean's legacy]. Gia created a large following of people who had never seen her move physically or heard her speak. That is an undeniable force of nature."

It may never be possible to reconstruct Gia's personality accurately or understand her fully. She was evasive, enigmatic, often contradictory, endlessly fascinating and charismatic. If Gia had lived, there can be no doubt she would one day have sat down to record the stories only she had witnessed, that she would have told *her* story. Fate, however—or, if you prefer, the consequences of bad decisions—had something else in mind.

And yet even those who aren't among Gia's admirers must acknowledge that she had an edge over others—both in the fashion business and in her everyday life. Born in Philadelphia, Pennsylvania, on January 29, 1960, Gia left this world only twenty-six years later. Death came in the form of an insidious enemy who took possession of her body and wore her down slowly, day by day.

November 2016 marks the thirtieth anniversary of Gia's death, and yet her memory is more alive today than ever. Her image has passed the test of time, and she has become—just like the ill-fated star mentioned by Hopson—one of pop culture's favorite icons. Little that is tangible remains of Gia, however—a few videos, all of them short, in which her voice can be heard, her physical movements observed, but her story and achievements are not commemorated in the way of other legendary figures who have left us too soon or too tragically.

What does remain are the enormous numbers of photographs taken of Gia. They fill the pages of magazines, books, and other

"holy" documents of the fashion industry. Often those photographs are remarkable, out of the ordinary, and their artistic value comes much more clearly from Gia's contribution than from the talent of her photographers. Something in Gia catches the eye of even the most casual observer. In her face, in her expressions, one discerns a vast repertoire of emotions. They speak directly to the hearts of those who admire her and tell a powerful story that goes beyond what words can say.

Gia Carangi was an unusual model in almost every respect. Hairstylist Michael Stevens summed her up in a single line: "She had a style that was her own: timeless and never before seen." She wasn't especially tall in terms of industry standards, and she was a brunette at a time when blondes were in vogue. More than anything else, she had a natural ability to move spontaneously, unselfconsciously, before the camera lens. Gia became a celebrity in the fashion industry in the blink of an eye ("It took her only two years to skyrocket," Suzanne Rodier says), and she worked with some of the greatest photographers of the twentieth century.

Her meteoric rise to the top of the modeling profession, however, proved to be a double-edged sword. The fame for which she cared so little nonetheless attracted individuals with questionable intentions. Their influence over her life was crucial to the events of Gia's brief adulthood.

Loyal, personable, generous, thoughtful, lovable, affectionate. Above and beyond her physical beauty, Gia had many other talents and won others over for her human qualities and for her sharp intelligence, her brilliant intuition.

Concludes Rodier, "She was beautiful. Enigmatic. There will never be another like her, that's for sure. She was definitely a supernova."

In loving memory of Gia

"We loved Gia with her 'imperfections.' She showed us that the important thing to succeed is attitude."

— Patricia Yurena Rodríguez
Model, Actress, First Runner-Up, Miss Universe 2013.

1

HI, I'M GIA

Philadelphia, January 1, 1976

The air of celebration extended even to the most remote corners of the city. That time of year had rolled around again, and all was in readiness for the traditional Mummers Parade, the procession of musicians, elaborately decorated floats, and lavish costumes that had greeted each new year in Philadelphia for more than two centuries. People began to fill the streets, moving together in a single direction, like a stream of ants: north on Broad Street.

The throngs of people on both sides of the street seemed to grow with each passing minute. From her car, Suzanne Rodier could see that much, and she knew she had no time to lose in finding a parking place. Still, she had to keep her eyes on the road: there were too many people rushing back and forth in front of her. Suddenly, her gaze came to rest on a scene of irresistible seduction, as if she had been drawn toward beauty by some deep and mysterious magnetism. This was no hallucination. She had really seen her! In the midst of all those people, she was really there. And she was gorgeous. So gorgeous, in fact, that Rodier couldn't stop looking at her. She wanted more time to get an-

other look, to imprint that lovely image in her mind—but damn! The car. She had to park somewhere, though she still hadn't seen anywhere she could stop. When she finally did, she hurriedly retraced her path on foot, back to where that splendor had appeared. But now the young woman was nowhere to be seen.

Rodier didn't dwell on it. Truth be told, she wasn't interested in tying herself down with a romantic relationship, and her behavior had made that fact clear on more than one occasion. Still, her brother kept trying to change her mind, doing everything in his power to convince her to accept one suggestion after another. "I have the perfect girl for you," he'd said more than once. But it was no use. Rodier was looking for a good time, and she took each day as it came. If true love happened to pluck at the strings of her heart, well, maybe then—but only then—would she let herself fall.

One evening, Rodier and her brother drove to DCA, a club in Philadelphia. As Rodier recalls the evening, her brother got out of the car first, while she remained inside, searching intently for something she had dropped. "All of a sudden," Rodier says, "the passenger door opened, and someone slid in next to me and put her arm around me. 'Hi, I'm Gia,' she said, and I was madly in love from that very second. It was the way she moved. It was her voice. The way she spoke. That's my first memory of her."

The young woman in the car, of course, was the one Rodier had seen at the Mummers Parade, the one she'd been so curious about—the one who had left an involuntary sigh on her lips: "Oh my God, she is gorgeous!" Months later, that vision finally had a name. The spark between the two of them was instantaneous, just like in the best fairy tales. "We started dating right away," Rodier says. "We dated for maybe a year, off and on. She was very physical. Very affectionate, very passionate, and very needy. Which I didn't mind."

The difference in their ages was no obstacle, though Rodier says she didn't actually know how old Gia was when they met. "She was a kid, but you didn't know she was a kid. You'd never

have known her age if you didn't know it. She was wise beyond her years."

Prospects for their love affair were bright. After all, their relationship was built on the most solid of foundations: the natural consequence of obeying the whims of fate. Rodier and Gia kept no secrets from one another, and communication between them, which often took the form of heartfelt talks, was good. Still, Rodier makes clear, Gia "preferred action" to thinking. "She was mysterious. She would [say], 'Don't talk about me. Don't tell anyone my business.' She wanted to be very private. She and I always had deep conversations, so she wasn't at all difficult for me to understand. I don't know how she was with other people."

Gia's parents had separated when she was only a teenager, and that "bothered her quite a bit," Rodier reveals. "She had a lot of confidence on the surface. But deep down, she was just a little girl who wanted her mommy and daddy to get back together again." Recalling an incident that illustrates the innocence of the young woman with whom she'd fallen hopelessly in love, Rodier continues, "My brother reminded me [of this], because I had forgotten all about it. Gia came to my house one day—this was after she had done a shoot with Maurice Tannenbaum [for] Saks Fifth Avenue, and he had crimped her hair. She came to my house, and she was so excited that she'd bought a crimping iron, and she [wanted to crimp] my hair, too. She said, 'I'm going to make you look exactly like me.' My brother heard that, and he started laughing. She just looked at him ... and said, 'Please, don't laugh!' That was one of her sweet, innocent moments. He said we were giggling like kids while we were doing it."

Gia's gentle nature was mixed with a large dose of unpredictability, however, a quality that managed to put a sparkle in her relationships. Rodier recalls another evening, after the two were a couple, when she went to meet Gia at DCA. When Rodier entered, Gia "was nowhere to be found. I was told that she'd gotten thrown out of the club because she started a fight with a man and was kicking him with her cowboy boots. My friends

said, 'She was in such a great mood. She was dancing, and the next thing we knew, she was beating this guy up!'" One thing was certain: Rodier was never bored in Gia's company.

Gia was sixteen years old. Life had smiled on her, and her future seemed rosy. At the same time, no one had failed to notice how beautiful she was, and it wouldn't be long before her name became a legend. Gia would go on to write some of the most impressive pages in the history of the fashion industry. Not a few of her achievements would never be repeated. Today, Gia Carangi remains an inspiration for designers whose collections are molded on her image and an idol for young women who eagerly aspire to a career in the spellbinding world of professional modeling.

New York, 1977

Ten years had passed since Wilhelmina Behmenburg (better known by her married name, Cooper), following a dazzling career as a model, had decided to combine all the experience she'd gained in her long years in the fashion industry and put it to use to help the new "recruits." In 1967, she took Sondra Scerca into her confidence (in addition to being Cooper's friend, Scerca also had considerable experience in the industry as both as a model and a makeup artist): Cooper wanted to open her own modeling agency. And that's precisely what she did.

Scerca set to work helping Cooper manage the new business. In 1977, a decade after she founded her agency, Cooper had established Wilhelmina Models as one of the most prestigious modeling agencies in the world. Her excellent reputation and expert eye had made all the difference. Like every agent worth her salt, Cooper was always on the lookout for talent and never wanted to let the best new prospects slip through her fingers. That was especially true for those young women who were part of a rare species, the ones every agent wanted to represent—the ones born with the "X" factor. Over the years, in fact, Eileen Ford, the top agent in her field, had discovered more than a few models

who had made the most of their gifts and gone on to become Hollywood actresses.

Cooper asked Scerca to call her whenever she noticed a young woman who had good prospects and who seemed a likely recruit for Cooper's "stable." The call didn't take long to come, and it forever changed the destiny of a simple young woman from Philadelphia.

Scerca well remembers the first time Gia and Cooper met. "Maurice [Tannenbaum] and I took Gia to meet Willy [Cooper]," she recalls. "It wasn't a long meeting. Willy asked Gia a few questions, and Gia was very nervous. Willy didn't measure or weigh her. She knew immediately that she wanted Gia to sign. After Wilhelmina met with Gia, she gave me the contract to give to Gia, and she said to me, 'Please make sure she signs that contract!' I gave Gia the contract as we were walking to the elevator with Maurice. We were the only ones there that day. Gia was underage and required a parental signature. Willy asked me to [let her know if] I ever saw anyone else I thought she should see, but I never brought anyone else to Willy. Gia's mother didn't come with us that day, as has been written in several accounts. We drove back to Maurice's house in New Hope. Gia was overwhelmed by what had transpired."

Delighted by the success of the meeting, Gia could return to the city of her birth and breathe a sigh of relief. The afternoon with Cooper had not only confirmed Gia's status as a true beauty, it had done something much more important. In Gia's lack of definite career aspirations, the meeting had given her a path to follow that would lead her on toward adulthood.

Gia's relationship with Suzanne Rodier, meanwhile, was heading in new and unexpected directions. The basis of their romance, which had once seemed unshakeable, suddenly began to crumble beneath an unexpected earthquake. The shift was immediately apparent to both of them, and Gia had no choice but to accept reality. Whatever sweet melody had once danced in their hearts, they'd both stopped hearing it. Rodier, in fact, had turned

her attentions to other horizons and Gia, like the phoenix, rose from the ashes. The two young women were mature enough—and their personalities were strong enough—that there was no room for hard feelings. Instead, a friendship was born that would provide a foundation for the rest of Gia's life.

When the time came for Gia to plan her move to New York, where destiny had called her, there was no doubt in Gia's mind that her ex would make the perfect roommate. She called Rodier, casually asked her what she was up to and then, as if revealing an ace up her sleeve, popped the question. Rodier accepted immediately. How could she turn down the chance to move to the city that never slept, where anything could happen, and where opportunities seemed to flow at one's feet like a waterfall? "We started going to New York on weekends, looking for places," Rodier remembers, and in February 1978 the two young women moved to New York. "We were both happy the first night in our new apartment in New York. Everything was playful and light and fun."

As they waited to "make it" in their respective professions, the future supermodel and the future celebrity makeup artist had to come to terms with the amount of money they found in their pockets. They made a virtue of necessity, including in their diet. In those early days, their most popular meal was the classic plate of beans and rice. Anyway, they thought, it was good for their figures. Gia, however, unlike other of her colleagues in modeling who checked their weight constantly to make sure they remained well within the industry's rigid standards, never worried about eating whatever she liked and as much as she liked. "She had a good appetite," Rodier confirms. "I can't remember her ever cooking a real meal, but I'm sure as she matured, she cooked for herself and for other people. But she did love to eat."

Gia immediately began to make herself at home in her new profession, though her reserve and inexperience still gave her some difficulty. Recalls Rodier, "She would go out to the clubs, but she was always a little shy. She always kind of stuck with

whomever she went with…. She was a teenager, and she couldn't really understand how she was getting so much work. In the beginning, when she would socialize with photographers, she was very uneasy. In front of the camera, though, she said something clicked in her. She was a different person. I think it's probably the same for a lot of actors: They're shy [but] once in front of the camera, it's a different story. Initially, she was very nervous about meeting people when she went on her 'go-sees.'"

It wasn't long before Gia joined the studio of Arthur Elgort, one of the best known masters of American photography. The occasion was a casting call for a Bloomingdale's campaign, and the crew in the studio included the Dutch hairstylist, Christiaan Houtenbos. Houtenbos had begun to work as a freelance hairstylist almost as soon as he arrived in New York in the 1960s, and his clients included top photographers, models, and musicians.

When it was Gia's turn to audition, the only doubt in the minds of the Bloomingdale representatives had to do with her height. Gia, who didn't quite measure up to the industry's minimum standard of 5'8," wasn't the kind of girl they were looking for. Bloomingdale's needed a model with a certain stature for the campaign they had in mind. Just at the point when Gia's last hope of being chosen for the job seemed about to evaporate, it was a woman who made the difference. Marianne Houtenbos, a fashion editor, Christiaan's wife, and Elgort's studio director and agent, who had sat in silence up until that point, suddenly spoke up. "This is a great girl," she said. Her words had the power of prophecy.

Christiaan Houtenbos recalls that Gia was a good fit for Elgort "because of her … beautiful face and more beautiful body. Height doesn't matter anymore when those things take over." Houtenbos continues, "[Marianne] booked her for our job, and, at the same time, she thought Chris von Wangenheim would appreciate [Gia], and she sent her straight over to Chris. He booked her right away…. [As] a hairdresser, and being intimately connected to these girls, I very quickly became aware that she was a 'girls' girl,' as I like to say, as opposed to a 'guys' girl,' but she wasn't the

only one. There were quite a few of those [in] all the generations of models from the day I started.

"We [traveled] a lot and spent time in close quarters, and knowing that a girl is a 'girl's girl,' you develop a more basically friendship relationship. I think that's what mattered in the long run with [us]. We were all 23, 24, 25, hot guys and hot girls, so there was always sexual tension among everybody at work. Between me and Gia, though, it was very quickly a pure friendship. I think, because of that, she was able to confide in me more than normal, but I certainly wasn't her best friend.

"These girls ... escape from home. They make their own lives. But there's an overriding thing with gay girls: They're always more independent, spunkier, more opinionated, and much less [likely to get] rolled over than other kinds of girls. That accounts for her being the type they called 'moody.' In other words, 'not in the mood.' Girls [like that] sometimes couldn't care less. They were not heedful of certain editors who ran the shows. They would defy them at times, simply by not showing up.

"I [recall] a job in Barbados where she came into my room and said, 'I'm going to stay here. Don't tell anybody!' And she would just not go to work in the morning. Even though we knew where she was and why she wasn't [at work], we would carry on.... It would drive the editors crazy. I happily obliged in all that because I always felt I would rather be closer to the girls than to the editor. The bottom line is, you have to work with the girls, and you can't do a good job with a girl who isn't willing, who's unfriendly or not in a good mood. So you have to go along with it, sit it out. A moment would come when the [model] would get up, and we'd be back in business. [In Gia's case], she would hide out in my room—nobody else's room. She let us know what was going on, but we kept it confidential [from others].

"She was a joy. She was very interesting and ... absolutely gorgeous. She had the most beautifully dimensional body—her legs, her breasts, all of it. A wonderful little face and thick hair, but the thing that sets certain girls apart also is their character, their

spunk. She certainly had loads of individuality.... You need girls who are expressive, who can move without too much direction. Not like it is now, where they're moving them a millimeter here or a millimeter there. We didn't do it like that. We just improvised situations and hoped that the girls would make something interesting of it. You'd just be shooting and moving their hair around and, in that respect, Gia was an extremely attractive subject.

"There is one anecdote that not too many people know. This was January 1980, a *Vogue* cover. The photography was by Irving Penn, and [Gia looked] as if she had cut her own bangs. But the fact of the matter was that, the night before the shoot—and this is the story Gia told—they were on a binge, smoking cigarettes, and she couldn't find a match or a lighter, so she [stuck her head] into the oven in the kitchen. In the process, she set fire to the front of her hair. She showed up the next day, and she basically had a burned bang. That got us to create a more properly stylish bang out of it. That was the reason why she looked the way she did. [They included a story in that issue]: 'Cutting Bangs.'"

Some say Gia wasn't too happy about the cut, but Houtenbos puts that rumor to rest. "I don't remember any controversy about the cut," he recalls, "but there may very well have been. There were always two camps around her: one wanting her to be a boy, the other a girl. Obviously the cut gave her more 'butchability.' But for sure it wasn't done against her wishes, and we remained on the best of terms until the end."

Photographers were delighted when Gia appeared on the scene, as were many of her fashion colleagues. The model Bill Curry was one of them, and he saw Gia as someone who brought an extra something special to the profession.

Curry relates, "I was working for Wilhelmina, and so I did work with [Gia] a few times when she first came to New York. I remember Gia being very sweet, polite, full of life, always fun. She always laughed, and she was like all of us—she was trying to make it in the business. At that time, the business was small and it was easier to break in. There were four agencies in New York,

and they represented pretty much the best talent in the world. As you know, she took off pretty quickly, and she started doing a [lot] of jobs very quickly. She was a beautiful brunette, and she looked very exotic in a way. Everybody kind of loved working with her because she was beautiful and she came out so well in photos."

The degree to which Gia was attracted to the fashion business is difficult to determine, but she was at least partially seduced by it, if for no other reason than the unimpeachable artistic caliber of the individuals with whom she was lucky enough to work. A sense of that allure comes through in an anecdote of Suzanne Rodier's from the period in which she and Gia shared an apartment in New York. "The first time we went to Studio 54 after moving to New York," Rodier recounts, "Gia had [been working] with Way Bandy [who became the best-known and highest paid makeup artist in the American fashion industry]. She came home, and she did my makeup. Usually she'd come home and say, 'This is what he did,' and I would do it on her, but this time she said, 'Come on, let's go to Studio [54].' I'll never forget: she did purple and green on my eyes."

After finding a place in Elgort's studio, Gia was welcomed through the doors of Chris von Wangenheim's atelier as well. There was an immediate rapport between the two. They were on the same wavelength in their approach to work and in perfect tune with regard to two issues that made every photograph a success: a meticulous perfectionism and boundless creativity. To make photographs he felt were worthy of his name, von Wangenheim turned his personal attention to even the smallest detail, an approach that required enviable teamwork, including a well-coordinated effort on the part of hairdressers and makeup artists.

Regarding von Wangenheim's work process, hairstylist Maury Hopson, who worked with von Wangenheim for years, says, "I miss him terribly. I did some of my best work with Chris. Because Chris had the patience. I mean, he would let you work and work and work until you got it right. And then he would take a beautiful photograph. But he knew what he wanted, and he knew

how to get it out of you. He was an inspiration. And I think Gia probably felt that from him, too. She knew she inspired him, obviously, and so she would never cause a problem at all with him. And he was a real artist, he really was. He was determined.

"He was also always sort of in the shadow of Helmut Newton, but he just adored Helmut, and he never did take the same kind of pictures that Helmut did. Because there was a period [in which] that kind of photography with Helmut, Chris, and Guy Bourdin [was everywhere]. There was an energy in it ... it had an edge to it. Chris had that kind of eye. I mean, he could make somebody [look] just beautiful. The girls never looked bad, no matter what. We used to say he should have been a hairdresser and a makeup artist because he understood that kind of thing so well. If something was the matter, he could tell you exactly what: It should be a little bit this way, a little bit that way, a little bit darker, or a little bit lighter. Whereas many photographers can say, 'This doesn't look right,' but they don't know what's wrong. Chris was able to tell you exactly what was wrong. And it was never in an unfriendly, demanding way. It was collaborative because he knew he was going to get his picture, if we all remained friends. So he didn't want to make any enemies, you know, trying to get a silly picture."

The symbiosis between Gia and von Wangenheim was profound, the rich insinuation of one world into another. They shared the occasional bout of pensiveness and inquietude, but they were bound to one another by a vital, unconventional impulse and by their keen ability to represent real life through art, even as they seemed to recoil from the ordinary and the commonplace and used artistic expression as a mechanism of escape. The meeting of the two artists (and Gia was an artist, despite what some may think of the profession of modeling; her expressiveness, worthy of the most celebrated divas of film, brought deeper significance to commercial photography) became an opportunity to experiment with new visions. What is more, their partnership allowed von Wangenheim to capture hidden desires

that Gia alone was able to absorb into the depths of her soul, interpreting them and giving them concrete form on the set, almost as if they had always been aspects of her persona.

Each time von Wangenheim photographed her, the enigmatic Gia revealed new nuances and undertones. She was avant-garde, "experimental," singular, no garden-variety model. Instead, Gia moved a great deal, her "licentious" poses exuding a sensuality that was never vulgar. In the fullness of her personal talent and charisma, in other words, Gia was everything von Wangenheim wanted in a creative partner. And yet, as Maury Hopson makes clear, von Wangenheim left nothing to chance, demanding no less than total commitment even from his beloved muse.

"Chris was the one who worked, who was a perfectionist," Hopson recalls. "He really demanded a lot. He would go on until four o'clock in the morning, easily. We were in Italy [once], shooting in the hotel, and [Chris was] in one of the suites with all the couture. He just kept shooting and shooting on Gia and Juli Foster. He just kept going, and they did, too. They were exhausted, but they knew Chris knew what he was after, and somehow that exhaustion worked in the photographs. The [models] had more of a vulnerability because they were exhausted. It didn't look like they were exhausted in the pictures, though [I] knew that's what caused them to look that way."

The photo shoot that Hopson describes appeared as a spread in the Italian edition of *Harper's Bazaar* in 1978. As Hopson mentions, the supermodel Juli Foster, one of the most beautiful faces of the era and one of the superstars of Wilhelmina Models, was also there. Foster recalls the shoot somewhat differently. "It was a very difficult one," she says. "As a matter of fact, we were locked in the suite for a couple of hours because Chris said we weren't behaving right, and he wasn't getting the shot. He locked the door from the outside and left us there for a while. It must have been three o'clock in the morning. He was really hard-tasking, and we were exhausted. Gia was crying and saying, 'I want my mom.'"

2

GORGEOUS FRIENDS

Suzanne Rodier, whose impressive professional credits include work on numerous high-profile commercials and more than twenty-five Hollywood films, including *Silent Life* (forthcoming in 2016 with Isabella Rossellini as the mother of Rudolph Valentino), for which Rodier headed the makeup department, knew Gia at the very beginning of her modeling career. At that point, Rodier recalls, "Gia did want to hang out with [other] models. But it wasn't because they were models. It had nothing to do with the fact that they were top models or up and coming [in the field]—it was because they were beautiful women."

Her desire to socialize with her stunning colleagues aside, most of the people with whom Gia worked tend to believe that Gia had no particularly close friendships with any of the other female models during her time in New York. The female supermodels with whom she formed genuine friendships, then, can be counted on the fingers of one hand—and Juli Foster was among them. The first congenial meeting between the two models took place in a dressing room, where Gia introduced herself in her uniquely "choreographic" style.

"Well, it's kind of a crazy story," Foster says. "What I remember very vividly is her just shocking everybody in the changing room. Gia liked taking her clothes off. She wasn't afraid of nudity. She liked to do this thing with her breasts that made them go in circles or something. I remember that very vividly. Everyone was shocked at her brazenness."

Once such formalities were out of the way, Gia and Foster quickly became friends. "We were very close," Foster says. "I enjoyed her. I don't know how to describe it; she was just an amazing person. I do remember times when she and I would walk down the street, and construction workers would whistle at her. Gia loved to flash them. She'd flash the construction workers, and then we'd run away as fast as we could," she recalls, laughing. "She'd just lift her shirt up. We'd be in hysterics, and we'd just run."

Gia always had a joke or a quip handy, but Foster had noticed right away that all was not as it seemed. Gia seemed to be lacking that *quelque chose* that would have made her life truly happy. Foster recalls that the two of them "used to laugh constantly. Gia was hilarious. I think she was enjoying herself. She enjoyed life. She was enjoying the things she was going through at the time. She was an incredible model. She just had that natural ability to charm the camera. Nevertheless, it's hard to say whether she really enjoyed the modeling because there was just that something lacking. I think something deep inside Gia was lacking. Nothing really gave her pure joy because something was always missing there. I think she enjoyed the modeling to a certain extent.... It's hard to describe it. She could be quiet when she was depressed.

"Mostly what I remember of Gia is how incredibly lonely and needy she was. She used to come to my apartment in the middle of the night—maybe one or two in the morning. She would ring my bell, wanting someone to hug. She just needed a friend, a physical presence. She'd take off all her clothes, get in my bed, and go to sleep. A lot of times in the morning, she'd be gone when I woke up. She just wanted to be around somebody. But she didn't open up to me that much."

Kim Charlton, one of the most beautiful and highly valued supermodels of the period, met Gia in 1979. "She was a beautiful girl, a nice model, and we all thought she was easy to get along with," Charlton recalls. "The first shoot I did with her, I remember we were up on the top floor of the World Trade Center. Big windows and the big city behind us—a beautiful setting, nice sunny day. And one of the first memories I have of her is that she pulled up her top while we were changing and said to me, 'Look how beautiful my breasts are!' And I said, 'Yeah, OK, wow!' I actually still remember them. They were round and beautiful and she was so proud of them.... That shows her personality. She was young and naïve. She was vulnerable. She was beautiful. She was fresh. She was excited about life. That's my memory of how naïve and how great she was."

At the time, the fashion industry was like one, big family. It included not solely work colleagues but groups of friends—people who shared the same interests and who got together almost every evening in Manhattan's trendiest clubs. Among these, the hangout preferred by female models was the world-famous Studio 54. Recalls Kim Charlton, a statuesque beauty who became the Ford Model Agency's top money-earner in the 1980s, "We hung out at Studio 54 a lot in the late seventies, early eighties.... There would be huge lines to get into the club, and we would just go up and the bouncers would open up the ropes, and we would go on in. The whole fashion industry was there. It was so much fun because you knew everybody and you [could] dance like crazy. I would see Gia there a lot, too. That was ... another side of her. We would be drinking—there was coke back then, too—but people had different levels of who did what. I didn't notice anything [other than that] she just was having fun, too, at that point."

But Charlton's "most wonderful memory" of Gia doesn't come from their epic nights at Studio 54, but rather from a time they shared a hotel room in Milan. "We were in Italy together for a *Harper's Bazaar* shoot," Charlton recalls, "and we booked a room at the Grand Hotel. It wasn't common back then to put two girls

together. I had a cover for *Harper's* in the morning, and I had to get [back to] the room to go to bed after dinner. I remember Gia coming in and waking me up to see if I wanted to go out some more. I said 'No,' because I had to rest [for my shoot]. So she went out again to have fun. A few hours later, I heard this noise, maybe it was three or four in the morning, and I remember Gia calling, 'Kim, Kim!' So I woke up, and what a beautiful vision. Gia was standing there naked, in the window at the Grand Hotel. I remember it had big stone windows, with sheer, long white curtains. The wind was blowing a bit—because the window was open— and her arms were stretched out on either side of the window frame ... she had the moonlight behind her.... I'm a painter, and because of that I'm very visual, and I still remember that vision perfectly.... It was beautiful. It was perfect. She came in and flew into bed, and we just went to sleep. As she knew, I wasn't into other things, but I was perfectly comfortable being with her, and that was it. In the morning, I got up and left her under the blankets, and then she got up and did her shoot. That is probably the best memory I have of her. She was so pretty."

3

A COUPLE OF WOLVES
IN NEW YORK CITY

The Russian-born photographer, Alexander "Sasha" Borodulin, son of the well-known Soviet sport photographer, Lev Borodulin, came to New York in the late 1970s with a dream of becoming a fashion photographer. In addition to winning professional success, the handsome, charming, and charismatic Borodulin also found his way into Gia's heart.

"I met Gia right after I got to New York in 1978," Borodulin recalls. "I met her at my photography studio, which was located in a very fashionable neighborhood across from the park on Central Park South. I was holding a casting call because I'd been hired to shoot something like eight pages in *Vogue*. There were about thirty women there from different agencies, and Gia was among them. When I met her, it was as if I was completely obsessed with her, right from the very first moment. I think she felt the same way because all the other models left after the call was over, but she stayed behind—and she didn't leave for two days! She didn't want to go. She had a special kind of allure. First of all, she was extremely beautiful. She was like some wild little animal, a gorgeous animal. She had that kind of magnetism that caused

everyone in the room to stop whatever they were doing when she walked in. Everyone fell in love with her. Everyone—my assistant, my makeup artist—they were all seriously drawn to her."

The relationship between Gia and Borodulin quickly evolved into a deep mutual understanding, but that didn't mean there weren't setbacks. Says Borodulin, "It was a very difficult relationship. Sure, it was more-or-less love at first sight for me, and she was definitely attracted to me, but she wasn't all that interested in men. So that was hard on both of us. She was attracted to me as a person, but I was attracted to her because she was a woman, so it turned into a very odd relationship. I don't think she was interested in guys at all, but I was very effeminate in those days, and that might have been what she saw in me that she found interesting. But I was 100% hetero. So that was hard. One minute she was in love with me, and the next minute she hated me, and then the next minute she was in love with me again. That's how it went. After I met her, we continued to spend time together, though sometimes we didn't see each other for two years or for a long time, then we'd be back together again."

With Borodulin, she started spending more time at New York's trendiest night spots, true temples to hedonism. "We used to go to the Mudd Club all the time," says Borodulin, "but the Mudd Club wasn't all that 'in.' It was just a cool place. Studio 54 was where things really happened. When they closed Studio 54, there were a lot of other clubs to go to—Limelight, Xenon—and we used to hang out at all these nightclubs. We started going to Hurrah. When Gia came to New York, Studio 54 was still open, but I remember we also used to go to Hurrah a lot because they had live music. We'd go to CBGB and other places, too."

Located at 77 White Street in downtown Manhattan, the Mudd Club opened its doors in 1978 (the club closed in 1983), quickly becoming the most popular hangout for fans of underground music and the counterculture. Artist and writer Richard Boch, who worked as the Mudd Club's doorman from 1979 to 1981, recalls the scene in this way. "Everybody went to the Mudd

Club," Boch says. "The MC was centered on the art-world, in lower Manhattan.... Everybody came there—from the old guard, meaning [people] like Robert Rauschenberg, Roy Lichtenstein, and the art dealer, Leo Castelli, to the new faces like Jean-Michel Basquiat, Keith Haring, [Julian] Schnabel, and Ross Bleckner [who owned the building that housed the Mudd Club].

"People came from all over the place, besides the artists. A lot of people who lived in the neighborhood or lived in lower Manhattan, in the Village, in SoHo, in what was becoming TriBeCa. Besides the artists and musicians, the people who were hanging out at CBGB in that scene in the mid-70s were [also] hanging out at the MC: the Ramones, the Dead Boys, Blondie, the Heart Breakers. People like that. The new wave crowd, the new wave dance [scene]. Then there were the celebrities, some of whom came regularly and some who just came to 'check it out.' There were people like the original cast of *Saturday Night Live*, who were there all the time. Sylvester Stallone dropped in—but it wasn't his thing. And then there were the models.... There were politicians who would come by. The crowd was very young because the drinking age in New York at that time was eighteen, and no one checked identification like they do today. The Rolling Stones would come there. The Kennedys would come there. I've heard that Gia was friends with Mick Jagger, but I don't know specifics. Anyway, we cast a big net, so to speak.

"It was a small club. It was two floors, but it wasn't big, so that's why there had to be a door policy, so that the people who were important to that scene or would create that scene [could get in]. Or the people in New York at that time who were contributing something—whether it was in fashion, music, or art. It was important that those people were able to come in, and that's basically what the MC was like.

"I remember Gia coming to the Mudd Club several times. I remember her from the second floor, which was more of a private area. Once inside the club, some people [went] up to the second floor.... There was no dance floor upstairs. It was more

like a lounge, and there was a bar. And yes, in my mind, she was quiet in the sense that she didn't hang out with a large crowd. She hung out with the friends who she usually came with. Mostly with a makeup artist, Sandy Linter.

"I have no memories of her being downstairs on the first floor or on the dance floor. I remember them coming to the door. They were very polite, especially Gia, and they never had to wait in line to get in. Still, they were also discreet.... They never had to tell me who they were, and I didn't have to ask. I just let them in. I knew who she was, and I knew she was well accepted. I remember them [mostly from] the eighties and not in the late seventies. The second floor was a very kind of a discreet place to be. This was in the days before there were paparazzi. We didn't let a lot of photographers into the Mudd Club—just the ones we knew—so people could sort of relax. They would or could misbehave if they wanted to within certain boundaries, but [I have no stories about Gia]. My memory of Gia is very simple.

"The MC had a self-service elevator that wasn't for use by the public. There were apartments above the MC, loft apartments. We used it as a service elevator, and the people that lived in the building also used it. Sometimes when I had to disappear for whatever reason—because I was just overwhelmed by the crowd at the door or I needed a break or whatever—I would go to the basement, either alone or with friends. We would take the elevator back upstairs to the second floor. When you stepped out of the elevator on the second floor, you were at the rear, and there were two bathrooms. Beyond that, there was a little area where there was some seating, and past that there was the bar, and then it opened up with booths, tables, and chairs. I remember one night, I stepped out of the elevator [on the second floor] and walked toward the bathroom. I saw Gia and the female makeup artist leaning against the wall. I looked at them, because I didn't know if they were going into the bathroom or coming out of the bathroom—the bathrooms were unisex. I said 'Oh, hi,' and they didn't say anything, but Gia smiled, and

that was it. So that's the memory I have of her—a good memory, a memory of her smiling."

Borodulin and Gia didn't do their clothes shopping at luxury boutiques "Elegant clothes weren't in fashion," Borodulin asserts. Instead, Gia preferred the *"garçonne"* look, which included jeans, men's shirts, and T-shirts—never anything but white. Borodulin recalls that Gia "liked to wear men's jackets, which she bought in second-hand stores. When punk arrived, she came to Paris, and I think she bought two T-shirts, one for me and one for her, with a skeleton on them. That was the first time I'd seen skeletons [on clothing]. When we wore them, we looked like Siamese twins."

Gia's look at work was completely different from the aspects she took on when she wasn't on the set. "It's the same for people in the movies or in fashion," Borodulin says. "There are always two distinct people: one on-screen and one in their private lives. In Gia's private life, her look was more of the *enfant terrible*, the boy from the wrong side of the tracks. She liked the attractiveness of her half-male, half-female appearance. She'd wear these big, heavy shoes, jeans, her sleeves rolled up, and she'd put makeup on very rarely in private, practically never. She liked leather jackets…. Clearly, she wasn't able to adapt to everything that was happening to her. She couldn't manage it, which is something that happens to a lot of people who have that truly magnetic personality."

Though they were a couple, the "Siamese twins" didn't flaunt their relationship in public. They wanted it to remain private, to steer clear of gossip and rumors. And so, though love affairs between photographers and their muses are part of the history of the fashion industry, Borodulin and Gia knew someone might have raised an eyebrow if the two of them ended up working together on the same photo shoot. Still, there were other reasons not to parade their relationship in front of everyone. "I don't know if I'd say we were together," Borodulin says. "That isn't exactly right. We saw each other quite a bit. But it wasn't cool to say

you were with someone, and if someone had asked me whether Gia was my girlfriend, I'd have said she wasn't. Or if someone had asked her if I was her boyfriend, she'd have said no. It wasn't cool to admit that. We were too tough. I wouldn't even take her for projects I was working on. I'd tell her she had ugly legs and that she was too short. I found millions of defects in her."

Gia wasn't shy about using her seductiveness as a weapon, as Borodulin well recalls. "She'd strip nude and [walk around in front of me]. She'd say, 'Look at me! Look how pretty I am!' She did it a lot. She was very narcissistic. She looked at herself quite often in the mirror and would study what she saw there—she'd study her breasts. She was fascinated by her own appearance. She'd stare at herself in the mirror and tell me, 'Look how gorgeous I am!' And I'd tell her, 'I don't see anything all that gorgeous.' It was kind of [verbal arm-wrestling].

"Gia was ambitious," Borodulin continues. "She knew she was going to become famous. She used to say, 'Take my picture because I'm going to be super-famous some day.' Even at the beginning when she wasn't famous yet. I've seen a lot of [models], but she had a magnetism that I've seen only rarely. I've photographed a lot of really gorgeous women. At the time, Gia was number one. She was ahead of the rest. She had personality and beauty. You know who else had that? I met Jack Nicholson once, about twenty-five years ago. I remember going to a party with some friends, but we didn't know anyone there. So we got there, and we saw that Jack Nicholson was there. But you know how the 'beautiful people' are—they all pretended not to see him or to recognize him, even if they all knew who he was. He was really famous then, far and above the rest. He had the same kind of magnetism as Gia. He came over to us and said, 'Hi, I'm Jack,' and the whole room came to a standstill. It was the same thing that happened when Gia came into a room—everything came to a halt. There's some kind of magnetic wave that people like that just release into the air. I had something like that, but it was never as strong as hers."

Borodulin also recalls that photography became an important

pastime for Gia. "I think she was really interested in photography," he relates. "She bought a Nikon. I wonder what became of all her negatives. I'd like to see them [now] because she was really talented. She took some excellent portraits of me that are still on the walls at my parents' house.... I taught her how to take pictures. She borrowed my camera and started taking photos, which is why I still have some of those shots, which are really beautiful. And she took photos of the two of us together. Unfortunately, she took most of them with her camera [and the photos have apparently been lost]."

Rodier confirms Gia's love for photography. Gia even "used to photograph homeless people in her neighborhood," Rodier recalls. "At one point, I think when I was living on 56th Street, she came to visit, and she tried to take photos of me. But I hated having my picture taken, so she would take angles without my face. But she loved photography, and she was a good photographer. Eventually she wanted to be a film director. That was her dream."

Gia's romantic life and her career seemed to be going at full tilt although, Borodulin recalls, Gia "started working too much. She was tired, and she needed to rest. Even a day or two would have been enough. The *Vogue* editors realized that, and they tried to protect her. They tried to convince her to take a few days off, which she certainly deserved. But Gia didn't feel like taking a break. The jobs, including really important ones, kept coming in thick and fast, and she thought she had to ride that wave of success before it passed.... So when Gia started showing the first signs of exhaustion, it was already too late. She told me once, 'Let's get out of here. If I don't get out of the house, they're going to send someone [to look for me].' In fact, it had come to that point. They'd send people to look for her in person because at the time there weren't cell phones, and she didn't even have a pager. If you weren't home, you weren't home, and the phone would just keep ringing."

Indeed, Gia often took refuge in Borodulin's studio. "She'd

come and tell me, 'We have to leave. If they figure out I'm here, they'll come looking for me here,'" he says. "She was the most sought-after person in fashion. For a while, she was the top model in the entire world." In fact, they couldn't stop talking about Gia in the fashion world, and she'd reached a level of fame that put her directly into the category of supermodel. But Gia didn't care about fashion or her fame, which seemed to expand from one day to the next. For some of the false friends who swarmed around her, though, the opportunities she represented were too tempting and had to be grabbed before they disappeared.

At some point in 1979—accounts seem to center on that date—Gia apparently made the acquaintance of someone in the fashion business who, instead of helping and protecting her as might have been expected, treated Gia with neither pity nor remorse. According to one respected name in the fashion industry (who spoke on condition of anonymity), "She got caught up with a fashion insider who introduced her to an 'alternative' lifestyle. She was very young at that time. I think this person played with her mind ... as far as [getting her involved with] heroin."

Though specific details are few, what isn't in doubt is that Gia's life slowly began to go off the rails around that time. She seemed to enter a dark tunnel, a nocturnal region of light and shadow worthy of Brassaï, but one in which the light soon became an unattainable mirage.

If Gia and Rodier's love affair had benefited from the absence of heroin, Borodulin's relationship with the model partially suffered from its presence. "I don't know a thing about how it happened," Borodulin says, "because I was completely opposed. We used to do cocaine together, and we smoked joints all the time, but I didn't do heroin. She got me to try it a few times, but I was afraid of becoming addicted."

Rodier, too, noticed Gia's new enthusiasm for "partying." She recalls that Gia "loved doing drugs. [When] she was in Philadelphia, I don't remember her ever doing drugs, and I don't remember ever seeing her do drugs, but right before we moved to New

York, when we used to [come to the city to visit], I noticed she loved coke."

But if the drug addiction that tormented Gia for years was, at least in part, the result of her contact with a villainous figure who hoped to *control* her, it is only fair to say that heroin unfortunately found fertile ground in Gia. Sasha Borodulin has a theory about why.

"She told me [heroin] relaxed her," Borodulin says. "Heroin is a downer, and she liked being relaxed. She didn't like Quaaludes, which were very popular then, because they completely whacked you out. Heroin calms you down, but you're still present. If someone had given her some Valium, I think that might have relaxed her, and that might have been enough, but there was no one to offer her advice. Now I'm old and stupid, but at least I've seen a thing or two. At the time, I was smart but completely inexperienced. We were like two wolf cubs loose in New York, trying to prove to everyone how cool we were. And we *were*— cool, and beautiful, and very 'in.'

"There was a certain amount of competition between the two of us to see who could be cooler than the other. We tried to act cool with each other, and that may have caused a certain coldness between us because we couldn't admit our weaknesses to one another or how much love and attraction we felt. That wasn't cool. Being detached was cool. Because of that, she was surrounded by people who were genuinely stupid. Most of them were true idiots, and the more heroin they did, the stupider they became, and that includes some of the friends she was closest to. I'm not saying they were bad people, but most of them were very uncouth and uneducated! I'd call myself an intellectual, and I was then, too. I read a lot. I went to see the important films. I was outside of the dominant culture at the time. But there are never a lot of people like that around at any given time, and she drifted off toward people who weren't up to her level. It was because, even though she had all this magnetism, she didn't have a lot of self-awareness. What she did have was great intuition, but instead

of using it to draw intelligence toward her, she used it to attract friends, half of whom were groupies and half of whom were interested in her for other reasons. She was already a star, and they gave her drugs so they could have some control over her. She liked drugs, and she'd go anywhere there were free drugs. I think that's where the heroin came from. A lot of the time, you didn't even know what you were taking. Once I was sniffing this stuff they called 'brown sugar,' and I was sure it was cocaine—but then I discovered it was actually heroin.

"We just didn't know enough," Borodulin reflects, "even though [we were] in the same situation. I was alone in New York, and so was she. It was easier for her, though, because she was American, and ... Philadelphia was two-and-a-half hours away [from New York]. In my case, I was from Moscow, which I could never go back to. At the time, if you left Moscow, you no longer had a country. You were a permanent exile. So my situation was more drastic than hers was. Like I said, though, we were like a couple of wolf cubs."

Under stress because of the increasing offers of work that kept coming her way and harried by the enormous expectations others had of her, Gia had dropped her guard for a moment. And then, betrayed by one of the people who was supposed to help her find her way in the fashion business, Gia drifted like an anchorless ship in a storm, at the mercy of fate. She had no one to count on but herself.

Suzanne Rodier has done more than a little soul-searching in her attempt to understand the roots of Gia's addiction. Her explanation centers on Gia's sense of self. "I think deep down inside she kept her humbleness," Rodier says, "and I think that's why she did drugs: because she didn't feel she deserved [her fame]. She didn't understand how it had happened. She may not have shown [that humbleness]; she may have shown herself in a different light.... But what the public saw wasn't the true Gia."

Gia's unease continued to grow, driven by the relentless question that tormented her: Why am I having so much success? She

didn't think she was worthy of it. Some might call Gia's concern nothing more than the paranoia of a young woman with low self-esteem, but Rodier makes clear that Gia naturally possessed a highly developed sense of fairness and equality. Her success, and the advantages she had been afforded, only amplified her perception of an "imbalance." That awareness led Gia to seek out people who were experiencing hardships or were less fortunate than she was, touching off even deeper levels of reflection regarding the injustices of the world.

"It wasn't just a question of being caught up in the fashion business and falling into the trap of drugs," Borodulin says emphatically. "I nearly died because of her [drug use]. One day she brought mushrooms to my apartment. I took so many of them that I thought I was going to die. We took mushrooms, and then she left me alone. I was in love with her, and she all but killed me. After that, I had to put some distance between us. Yes, I was in love with her, but on the other hand I couldn't compete with her anymore. She'd become a celebrity. And the heroin made it impossible to stay with her. We'd go to the movies, for example, and she'd say 'I have to go to the bathroom,' and she'd disappear. Or we'd get together and fifteen minutes later she'd leave because she had to be someplace else. I'd almost call our relationship inhumane. I kept being more and more in love with her, and I was getting more and more depressed—but not her. Or, at least, I couldn't see any signs of it. And then I'd get angry with her because of how crazy she was making me. I would see her with all these people who were really human garbage, and she'd bring them to my apartment and introduce them to me. But it was all a waste of time. We'd just sit there and do drugs, but those people had nothing whatever to do with my life.

"It wasn't easy being with her. At first, it was wonderful. I don't remember the exact sequence of events, but I do remember how I felt. I know I met her not long after she got to New York, and we continued to see each other for the rest of her life. She died in 1986 and I met her in 1978, so I knew her for eight years.

At the beginning, we spent a lot of time together—almost every day. That lasted five or six months. She drove me completely crazy. I lost my apartment, my job, nearly my life. Then I moved to Paris, and I went back and forth, still seeing her because she kept calling me, but I was holding back because I was hurt. But she called me and invited me to her new apartment, and I went.... Or she'd say, 'What are you up to? Let's go to Philadelphia' and, since I was still sort of in love with her, [I was tempted]. But [I had started living] with a model in Paris, and ... I was trying to make it as a photographer in both places, so I'd be in Paris two weeks and then two weeks in New York. My girlfriend had also been on the cover of *Vogue*, and she was the number-one model in Europe. So I stayed there, but Gia didn't come to Europe very often. [At the time], there weren't cell phones or social networking or any of that."

4

THE ACAPULCO EXPERIENCE

For New York photographer Andrew Brucker, at the time Mike Reinhardt's photo assistant, the evening on which Alexander Borodulin introduced him to Gia was the opening act of a dream.

Recounted Brucker, "It was in late summer or the fall of 1978 when I found myself in Studio 54, a place I spent much of my time at night, having fun. I vividly remember looking across the main room toward the dance floor, where I spotted an acquaintance of mine, a Russian photographer [Borodulin], speaking with a uniquely beautiful girl. He knew all the girls, especially the cool ones. She was different from the others in how she dressed and in her body language. She wasn't dressed in disco style. She had a punk edge, like an ultra-feminine Patti Smith.

"When my friend finished speaking with her, I ran over and asked him who she was. He said, 'Come, I'll introduce her to you.' It took me by surprise and I hesitated, but he assured me she was cool and it would be fine. So, in the noise of this famous club, I met Gia. I didn't have much to say. I was intimidated by her, and it was loud. Our faces were close to each other as we exchanged names. I said something ordinary like, 'Are you a

model?' or 'What agency are you with?' I told her I worked for Michael Reinhardt, and I can't remember what else. It was short, but I was smitten. She had a look in her eye that was pure mischief. She was smaller than most of the models, which I liked, since I'm only 5'8."

"I arrived at work that next day and told my boss, who at the time was a big fashion star and was dating Janice Dickinson, that I had met the future. Her name was Gia, and we had to book her. He laughed and told me I was probably stoned when I met her, and what did I know. I was new to the business, that was true, but I had breathed her air and looked into those eyes. She was only eighteen and just getting started. He finally held what they call a 'cattle call,' and I found myself in the studio with [all kinds of] girls coming and going—and Gia was one of them. We winked at each other from [across the room]. She left, and I hoped he would agree with me and start working with her. But he wasn't impressed, and I felt it was only because I was crazy about her.

"Weeks later, much to my surprise, I came to work and heard Mike arguing with someone on the phone about how he must have first option on Gia for an important shoot we had scheduled. I couldn't believe my ears. Gia had arrived! Overnight she was becoming the new *it* girl and my dreams were coming true.

"In early 1979, January or February, we flew to Acapulco for American *Vogue*. Gia Carangi, Patti Hansen, Janice Dickinson, and Michael Holder were the models. Jade Hobson was the editor, and Rick Gillette was on hair and makeup. I was thrilled to be going as the only assistant. It was on the flight that the fun-loving, mischievous Gia presented herself. She teased me by throwing bits of this or that at me where I sat, several rows in front of her. When I turned around, her eyes would widen and she would make faces. I [was under] enormous pressure to perform my duties as an assistant, but I could only think about the week ahead and what adventures we might all have. We had three of the coolest girls in the business with us, and I'd never felt luckier.

"As we began to settle in [in Acapulco], it was clear that the

gang wanted to have fun. I roomed with Michael Holder, the male model, and Gia and Patti shared a room. Janice, of course, was with Reinhardt. We all worked hard, but in the evenings we let our hair down. I wasn't supposed to [join them], and my boss let me know in no uncertain terms that I was to keep the girls from partying and going out. As if I could tell Patti and Gia to behave themselves. They knew I would be easy so we, the models, me, and the driver, went to town and had fun. I found myself in big trouble the next morning—I was told it was all my fault that the models were tired. After that we partied quietly at the house.

"I will never discuss the personal details of anyone's adventures, but I can share one special 'intimate' evening with Gia. We played like teenagers but never took it all the way. She wouldn't let that happen. She knew something about herself I didn't. We became friends on that trip, and I think, if I had been a girl, we might have had a chance. We never kissed again.... It was like hanging out with a good buddy. She was funny, irreverent, shocking, and slightly mad. At eighteen, it all worked beautifully for her.

"When we returned to New York, the honeymoon was over for me. I was interested in a relationship she couldn't give me, and I was too stupid, young, and immature to realize that I could have been a good friend. I drifted away and lost the chance to know a remarkable person."

The Gia Andrew Brucker saw was happy, enthusiastic about what was taking place in her life, and in no way struggling to manage her success. "She was beginning her life as a model," he recalls, "and she was very eager. She was a lot of fun, and she was having a lot of fun.... Even though it was at the beginning, everything was perfect at that time. It was all exploding for her. I think she was very happy about all of the good things that were coming her way. The girl I knew was eighteen-years-old [and she] was joyful and full of mischief. She had a great sense of humor, and she liked practical jokes.... You have to understand that I only knew her closely for a few months, so I can't say she was my dearest friend.... She didn't open up completely. All I

[recall] was her being a very flirtatious, mischievous young girl. She was elated that all of these wonderful things were happening to her and [that] she was getting enormous attention. I think it took her about two years after to [stop] being happy with all of the attention. Everybody wanted something from Gia.... You know how it works: Everybody's very excited when there's a new young boy or girl in the business, and they throw them [into the ring] to see [what will happen]. Some are strong, and they survive and manage it. Some are going to be eaten up by it. I think she managed it quite well. I think at eighteen she was happy to have such an opportunity. She wanted to be a filmmaker. I know she loved movies."

Within a few months of meeting Gia at Studio 54, Brucker says "every photographer in the city wanted to work with her." During the American *Vogue* shoot in Acapulco, he continues, "I never heard her say, 'I hate modeling. This is not what I want.' She was very happy for the attention." At the same time, Brucker also observed Gia's "classic guarded personality. If she heard or saw something in a person that she didn't like, she would do one of two things: either make fun of that person—not in a mean way, but [clowning or joking], or she would ignore him. For example, she would tease my boss, Michael. She knew he was a playboy, and she knew he liked a lot of women, and so [she made fun of him]. He was a tough man, so she would pull his pants down, or she would make funny faces behind his back—stick her tongue out or cross her eyes. She would just goof on him, and he would even catch her and say, 'Gia now stop it! We have to work!' She was always like a little clown with him."

Gia had a similar approach to people she actually did like, however, as Brucker also confirms. "That's what she would do with people she liked," he says, "she would make fun of them! And it was the same with me. She was always trying to pull my pants down, or she'd jump on my back and put her arms around me and bite my ears. She would do funny things. It was cute and she was happy!

"In this business, when a young model starts becoming popular, she [sometimes] develops a personality that isn't always easy to handle—a bit arrogant. Some girls have [that arrogance]; some are very nice and polite ... and respectful and maybe a little boring. But Gia wasn't boring. Gia was so insane—in a good way. She [acted like she] was hanging out with her best buddies.... Certainly with Patti [Hansen] and Janice [Dickinson], who were on this *Vogue* shoot, they all got along with her just fine. Some girls are very strange, and they go to their rooms by themselves and aren't social, and everybody whispers, 'Oh, she's too cool [for us]' or 'What's her problem?' But not Gia. She was up for the party! We would go swimming at night, and everybody would take their clothes off ... and she was there.

Brucker was falling in love with Gia during their time together in Acapulco, he acknowledges, which likely colored the nature of their conversations. Though they did sometimes discuss personal issues, he "tried to keep the conversation light, to be charming," understanding that Gia would probably have been reluctant to discuss her family or other intimate topics in depth with any person she had only recently met. Still, he adds, "I don't think she was doing any drugs at that time. I didn't feel she was, and I never saw anything.... At that point, I think she was ... excited about life, and so happy to be meeting so many interesting people." In Brucker's view, Gia may later have experienced a not-uncommon change of heart for people as they become more experienced in the business: eager at first and then, when groupies and paparazzi appear on the scene, increasingly insistent on maintaining at least a semblance of privacy. But Gia's enthusiasm in those early days was infectious, Brucker says: "How could I not fall in love with her?

"The cool part about her was that she wasn't a tomboy. She was very feminine, or at least I saw her that way. Her body, her face. She would come in the room and say, 'Come on, let's take some nudes. Let's photograph my ass,' and I would say, 'Gia what are you talking about?' And she'd say, 'Get the Polaroid.' So we would take these sort of racy pictures in a funny way and we

would look at them and laugh, and then she would take them away from me and tell me, 'You can't have these.' She was just a kid! A good crazy kid! Always fun, always touching me, and very comfortable touching [other] people. Nothing dark about Gia, let me tell you. At the time, she was fun and [full of] life. Those are the only memories I have.

"I think maybe later, when she became a drug addict, it [was] very hard to maintain that—not just for her but for everybody. She was famous and hanging out with the Rolling Stones, but she was alone. She had an agent [who] tried to look out for her, but the truth is they didn't really care.... Through the years I would hear stories and shake my head, but I figured she would survive like so many of my wild heroes [did]. I saw her once up at Elite [Model Management] around 1982 or 1983, and her shaky appearance was obvious. I remember the dark circles under her eyes, and I wondered if she would be all right.

"I was sad I didn't stay her friend. Not that I could have changed anything. But I wish I had been more of a grown up. If I'd been more mature ... but at the time, she was a friend, and I was thinking she [might be] my girlfriend, or maybe that [we'd have] an affair.... I should have said, 'OK, let's be friends,' and I would have gotten to know this girl better, and maybe she would have seen that I could be a good friend. Instead, I ran the other way. I was a young kid, too.... I do believe if she hadn't gotten AIDS she would have come out the other end and surprised us all."

Michael Holder, the only male model at the photo shoot, recalls his experience at the *Vogue* shoot in Mexico this way: "I was the prop for a swimwear spread shot by Mike Reinhardt with Gia, Patti Hansen, and Janice Dickinson. I had only been modeling a few months. I had worked with Mike before, but not the young women." The location for the shoot was what Holder called a "spectacular villa" on the beach near Acapulco, and he recalls meeting Gia for the first time "on the transit bus going from the airport to the villa. She had a Sony Walkman and was listening and dancing to Rod Stewart's *Do You Think I'm Sexy* over

and over. She went through several packs of batteries over the days we were there. Her movements were fluid but subdued; her expression was more ironic than emotive. I don't think we spoke at all the whole [bus] trip. She did bum a couple of smokes off me, using her eyes and hand gestures."

Holder recalls that Gia's presence was marked both by "self-sufficiency" and an awareness of "everything going on around her," a definite contrast to what Holder recalls as "Janice's frenetic, hyperactive personality. Mike had Janice wear a dog collar and put her on a real leash, but he forgot the muzzle and chastity belt. She never shut up and stayed naked all day. Mike's young assistant photographer was so enamored of Gia, he could barely concentrate on his job. She acted the demure princess to his awkward puppy dog. I found their behavior sweet, although I could see he was in serious pain. Patti [Hansen] arrived a couple of days into the shoot. Mike ordered us all to go to bed early, but Patti would have none of that. She wanted to go out dancing, so I accompanied her to some disco in Acapulco where a room full of men proceeded to fall over themselves and fight with each other to be near her. When we returned to the villa around four a.m., we found the assistant, Andrew, lying on a chaise by the pool, staring up at the stars.

"Gia seemed very modest about dressing and wearing swimwear, especially compared to Patti, who was relaxed, and Janice [who was an] exhibitionist. You can see from the photos. When the camera was on, Gia turned on the light. She was very young and perfectly professional. I have no idea whether or not Gia was happy. I may be projecting, but my sense was that she thought modeling was a pretty silly job."

5

WOMAN INTO MAN

Following the success of the world-famous photograph entitled *Rue Aubriot* (after the Paris street on which the German genius, Helmut Newton, had immortalized Vibeke Knudsen wearing an Yves Saint Laurent tuxedo in 1975), Newton came up with a brand new take on gender-bending. His new photograph retraced the themes of the earlier shot, which had become one of most iconic photographs in the history of the fashion industry. The model Robin Osler was the co-star of the unforgettable photo shoot. The booking—for French *Vogue*—had come relatively early in Osler's professional career. She'd arrived in Paris in 1978 and had only just begun working as a model. She had appeared in Fall collection fashion shows, and her very first photo-booking had been with Newton. After that initial job, she worked with Newton regularly.

Recalls Osler, "I didn't know who was going to be on the [*Vogue*] shoot until later, and I had been sent to a store to try on men's suits. That's where I found out the details of who was going to be on the shoot: Gia and Bitten Knudsen.... At that point, Gia and Bitten were pretty big stars in the United States and had had a number of covers, so I was sort of a newbie going into all

of this. I had worked at French *Vogue* a few times before with Helmut, so I was familiar with the studios and dressing rooms and the canteen downstairs and [the locations where] we were shooting around Paris. I remember Gia seemed a bit irreverent, but in a way that was refreshing.

"There was actually a lot of [drug use] going on [in] my generation as a model. There were a lot of drugs. But Gia certainly wasn't high, or [at least] she was completely normal on the set. She worked hard, and she was very, very nice to me and to the other girls. Both Bitten and Gia were very nice. We were all in it together, and it was a good shoot. Nobody threw tantrums, nobody copped an attitude. Nobody pulling rank or anything. It was four girls with this amazing photographer, working hard and doing good work, *dynamic* work. It was a great experience!

"Helmut ran a pretty tight ship. He wouldn't tolerate attitude or dramas. What I recall from the shoot [is that there was no] issue at all with Gia. She wasn't difficult even though it was two famous girls from New York working with two newcomers who were living in Europe. Most of the shots were taken at the George V Hotel, on the lower level. Times were different then. You didn't have many models who were paid so much more than others, which meant there was less conflict. And the business environment was different from what it is today. When the banks became involved and infused it with millions and millions of dollars, the entire industry changed.

"There were a couple of moments I remember specifically: one was when we were actually doing that famous photograph, where Gia's leaning back, and I'm leaning over her, lighting the cigarette. We were actually having a very hard time keeping a straight face. The smoke was getting in [both our] eyes. Helmut worked [in such a] way that you would have to hold a position for a very long time, and you would just move little things, like a finger. For that shoot, it was all about my hand because [that's what] he wanted to photograph. The [image was meant to conjure up] a man and a woman, but [if] you looked at my hand, you saw that

it wasn't like a man's hand at all. Helmut was directing me to 'hold your finger up just a little' while Gia and I were trying to stay still with smoke in our eyes—and giggling.

"When you're in the shot, you're just trying to get through it, and I remember it was stressful, probably more stressful for me because I was just beginning. When you're starting out, you need pictures, and at the time I thought 'Well, I'm not going to get any pictures out of this. I'm dressed like a man.' When I was booked, I thought it would be similar to the famous shot Helmut did on a backstreet of Paris [*Rue Aubriot*] with women's clothes cut like men's. But these were actual men's clothes. They put dark blush on my jaw to make it look like I had a little bit of a shadow [from a beard]. For me it was a strange experience, making me wonder who I was as a model.... When the feature came out, I was quite worried. I remember opening the magazine very gingerly, but when I found the pictures I was amazed, because they were fantastic photographs."

"Gia and Bitten were the stars, so they [got] to wear all these fabulous clothes while Karina and I were dressed as men. And I remember sharing my anxiety with Gia. Her response was, 'Oh, I'd love to be doing what you're doing. I'd love to be wearing the men's clothes!' And I said, 'You can say that because you've got twenty covers. I don't have any of that yet.' She seemed to understand my concerns and was very supportive. I remember sitting at the makeup table fixing something on my face, and Gia was standing behind me with her shirt off. She had this amazing body, and I complimented her, 'You have the most beautiful boobs I have ever seen!' I said. ' She got a kick out of that. She was so fresh and very unpretentious. There was something real about her. So I had a very good experience with her. It was early, before she got into drugs. Looking back, I can see there was this slight vulnerability about her.... She was in a completely different environment from what I think she was accustomed to.

"I felt very grateful that I had the career I did and that I had the opportunity to work extensively with Helmut. I mean, I feel

very, very lucky. I think a lot of people felt that way working with him, [though] many people didn't. I've run into other girls who said they really hated working with him, and they worked with him a lot. In retrospect, I respected his talent as a photographer.... Helmut always treated everyone [well]. It was work—good work. There were never any of the weird vibes that could go on with other photographers. Helmut was very serious about his work. He was a totally competent professional. I have fairly warm memories of working with Gia on that shoot. And it became an iconic photo.

"Unfortunately, Gia didn't make it. She wasn't a survivor. I was surprised when I heard later on what had happened to her. Before she died I'd heard she was going off the deep end. My sense of that has always been—and I'd seen it happen with other girls in the industry—that the industry certainly didn't help anyone [who] needed it. They were chilly toward this sort of thing. If the papers were to [mention how] someone was strung out at a fashion show, it became something to talk about—in a gossipy way, instead of realizing there was a problem and that this person was crying out for help. Someone needed to help her instead of booking her, to get her into treatment, and nobody did that. It is terribly sad. There was something in her that was extremely vulnerable. Sometimes I wonder if it was a combination of her background ... and also being gay in an environment in which gay women at that time were not out.... It was one thing to be a gay man in the industry. That was very normal. But for gay women, it wasn't even on the radar. I think she was struggling with all of that, which is sad, because it wouldn't have mattered to any of us."

6

LIKE BUGS BUNNY

Gia and Sasha Borodulin often went out with a gang of friends that included the well-known hairdresser, Edward Tricomi who, with Joel Warren, today owns the Warren-Tricomi Salon at the Plaza Hotel in New York City. Tricomi, whom some called "Edward Scissorhands," recalls meeting Gia "through an ex-girlfriend of mine by the name of Robin. There was the group of us that used to hang out together—Gia, myself, Robin, photographer Sasha Borodulin, and his assistant John. We were always [together]. We were all young kids, we were all in the industry, we were all doing magazines like *Vogue* and so on, and we used to hang out together. As a person Gia was interesting. She was a character, like Bugs Bunny. She was like Madonna. Madonna has this sense of humor, and it interests you—kind of a wisecracker. Gia had that kind of sense of humor, like Madonna, a very fast, cunning sense of humor."

Tricomi also had a chance to see Gia in one of her happy moments. "After Gia started to make it, one day she bought a car," he recalls. "She showed up with the car—it was a convertible—and she was all excited about it. We all took a ride. It was like that. We were very good friends."

Tricomi isn't the only one who remembers Gia's car, however. Gia, driving like a stuntman in *Fast & Furious*, also took Suzanne Rodier for a spin, and Rodier, even decades later, can bring to mind every emotion. "I took a ride with her around Central Park when she bought a new car, and it was the most frightening experience of my life," Rodier says. "She was a lunatic behind the wheel."

From Tricomi's perspective, however, "Gia wasn't impressed with the business or anything in it. She was working and doing the thing, but all the hype that went along with it and everything else—she didn't give a shit." In particular, Tricomi recalls a shoot he did with Gia in Europe. "We were working with Vera Wang [who] was the editor," Tricomi says. "We were working for *Vogue*, and Andrea Blanch was the photographer. The night before we had gone out, Gia and I. We were out until maybe 2 or 2:30 in the morning and I said, 'We've got to get home. We have to get up early tomorrow for work.' So I finally got her to the hotel, and I sat on her because I knew she wanted to split, and I didn't want her to because [I knew] she was looking for drugs. So I sat on her to make sure she didn't take off.

"Next morning, we got up. We did hair and makeup. We got her all ready. We did one shot, and she had a ten-thousand-dollar gown on her. She split and went to the airport and flew home, and we didn't know it. By the time we figured that out—half-hour, an hour later—we couldn't find her. Vera was freaked out because she said, 'She's got the dress!'

"It was really crazy, because we had to get another model—and the whole time not knowing she'd flown home. When I got back [to New York]—Gia was living with me at the time—the dress was hanging in my bathroom. I said, 'We've got to call Vera. I have to tell her.' At that point Gia was really starting to use drugs, and she was having problems. I kept on telling her, 'You've got to get yourself together,' and I finally convinced her to go home. Then I called her mom and I said, 'Listen, you've got to take care of your daughter, because if not, she is going to kill herself.'

"So finally I got her to go home, and I didn't hear from her [again]. Then the next thing I heard was that she was dead, and that freaked me out. I knew she was living in Philadelphia, which is where she was from. It was really crazy, you know? We lost a lot of people in those days because of AIDS.

"I don't know what happened when she went back. I think that the boyfriend tried to do something, or she got into a fight with her mom and the boyfriend, and then she went on the street on her own. She had such a mouth that she could start a fight with anybody, you know what I mean? I can't imagine what went down. She would say it like it is. She had a very fast mouth! And if you weren't strong, she'd kill you! She was brilliant!"

Recalling Gia's "fast mouth," Tricomi nearly doubles over with laughter before he continues: "I don't think she had mental disorders. I think she got caught up in a whole scene that she wasn't prepared for. I think she got caught up. Listen, the scene in New York—if you weren't smart, you could get yourself in a lot of trouble. I know a lot of people [who did]. Very, very sad. My ex-girlfriend, she died of AIDS. You know, I broke up with this girl, and then she met a guy that was doing heroin and she got infected [with HIV], and then she had a baby. And I got her to rehab and she got her stuff together, and after that she was fine. She lived fifteen years, and then she died from the disease.

"A lot of people got into trouble in those days because there were tons of drugs. Not only pot but drugs. People going out for [drugs] every night or every other night.... New York was really crazy ... a really, wild, wild, wild west scene, and age wasn't an issue. Some people were wild with their sexuality. In every respect they were wild. So I think Gia landed in that. The modeling business at the time was really crazy and wild, and she couldn't navigate it. She wasn't ready to handle all of that. And then success started coming, and she made money, and then the drug addiction kicked in and fucked it all up.

"She didn't think of it as a business, you know? She was a 22, 23-year-old kid, just living day to day. So if she had to get up,

but she was hung up, she didn't go to work. If she wasn't hung up, then she went to work. People were trying to book her [because] she was a big money-maker. People were trying to [work] with her, and I believe that physically and emotionally she was scraping the bottom. She had a lot of burdens, and I think that emotionally she was lashing out at things. You could see that, but drugs didn't help. I think she had mixed feelings [about the fashion business]. She was making money, but she really didn't care about modeling. I mean, she didn't care about all the hype. Being a model was a big thing, and people would say, 'Oh, you're so beautiful.' She couldn't [have given] a shit less. You know: 'Don't tell me I'm beautiful. I don't give a shit.'

"I'm sure she liked some of her jobs—some takes here and there, when she was working with decent people. If she liked you, she loved you! But if she didn't like you, she'd kill you," he laughs. "There was no in-between. I knew a few people who worked well with her—there was Michael, there was myself, there was Sasha—because we'd known her from the very beginning, and we didn't care. For us and with us, she was just Gia. We used to goof on her and she would goof on us. But I watched people stutter around her. She would make people stutter. I used to say, 'Gia, you are so fucking mean. What did you say out there?' She wouldn't even care. Sharp personality, sharp mouth.

"I mean her thing was that people were impressed with her, and she didn't give a shit if they were impressed. Maybe it was a game she was playing, in a sense. But [when] people, especially in the industry, saw she'd started becoming a big model, a big name, they'd be falling all over her. Photographers and all that, but she didn't give a shit. People were trying to help her [and] people loved working with her. She was a great model. She had a great face, a great body.

"When she first came to New York, she was very young, and she was on her own. In that respect, there was a lot of confusion for her. When she started to become successful in this business, everybody was going after [her], seeking [her] out, and I think

that it really started to affect her. But as far as a person, she had a good heart. She was a good person. She had a defense mechanism that she worked. She wouldn't let people get too close to her. Very few people got close to her, and you had to be really, really a good person to get close to her.

"I've seen this with a lot of people. They get afraid of success a lot of times. When success finally comes to them, they don't know how to handle it, and what they do is, they blow it up. They blow it up somehow. They either get into drugs or fight with everybody around them, or they do stuff to destroy their success because inside themselves they don't believe they really deserve success. So I think, in some respects, Gia was probably battling that. When she got to New York City at eighteen years old, it was a lot to handle and then [there was] all the shit of this business. You've got editors trying to sleep with you, photographers trying to sleep with you, everybody trying to sleep with you. Drugs going on, people partying, and then it gets out of hand, and you get in trouble. I think this kid, she got lost in that craziness. I can even say this for myself. I was lucky. I could have gotten myself into more trouble than was necessary, but believe me, there was all kinds of stuff to navigate—the business and the people. It was very crazy. Everybody, plenty of other models, did crazy stuff. They were very wild. I lived with a lot of models. A lot of people came and went over the years.

"But, I mean, if you needed money or if you needed anything, she would give it to you. I have to say that certainly Gia was a very good person. You know, she got in over her head. For whatever reason, she couldn't handle it emotionally [and] that made her do drugs. I mean, we were all doing drugs, but she got into bad ones. Heroin is a bad one. I would never touch that shit, [but] it was a fact at the time, and she got hooked into that ... and became a victim of it like a lot of other people. I remember we used to all go to the Mudd Club. At Studio 54, the thing had been cocaine, and then [when they closed Studio 54] and the Mudd Club opened, heroin came in. You know... people were doing

heroin, and punk was really raging in New York at the time. And she got hung up with it."

As Gia's unstoppable star continued to rise, she began to breathe ever more rarified air. As Sasha Borodulin reveals, "We were meeting famous people all the time, and we'd shoot the breeze with them, joke around. Gia was the number one model. I saw Andy Warhol and Gia together a bunch of times. He and Gia liked one another a lot.

Jimmy Destri, keyboardist for the legendary new wave and punk rock band, Blondie, recalls Gia very well. "I really don't remember the year we met," he says, "but there was a club called Hurrah and we [had backstage passes] for a show. My friend, John Brown, who was a writer, had met Gia earlier. He had just published his first novel, and he met Gia at some function and brought her to Hurrah. She and I started talking. She seemed so adventurous and happy, a wonderful girl. [After that] we struck up a friendship. She was warm, loving, very sweet, and somewhat lonely. She was a listener. I'm not a psychologist, but she was carrying a sort of melancholy, a sense of dissatisfaction. But she was one of the most beautiful girls I have ever seen. Everything about her just spelled 'class.' She was a very classy lady. But she was also pretty wild. She would outdrink you at the bar, and she'd be laughing all the time and hanging out with the boys and having fun, drinking shot after shot. At the same time, she seemed unfulfilled. We talked a lot about life and what she wanted to do ... but nobody knew what she wanted to do."

It was Destri's idea—"All mine!" he says—to include Gia in the music video of Blondie's hit single, "Atomic." Destri recalls that he "spent too much money on that video, and the whole band got mad at me. I did all it took to make it big, but it became a huge hit." He also remembers an embarrassing but amusing moment at a charity event at Hurrah, where Blondie appeared. Laughing, Destri recounts that Gia "fell on the stairs! Yoko Ono sponsored [the event], and we played a couple of John Lennon songs. I was singing one and playing the piano, and I looked to

my left where there was a little stairway that led to the back of the stage." Expecting Gia to come backstage when he had finished playing, Destri "mouthed, 'Gia, come on!' She climbed the stairs and fell. She got up laughing like [it was] the funniest thing in the world—meanwhile I thought she broke a leg or something, but she was fine. And seeing this beautiful, very statuesque woman fall on the stairs like Charlie Chaplin was truly funny. She was very cute when she did it.

"When she died, I was so sad ... such a sad day. She's somebody I'd like to know now and be friends with. [She had such] magnetism. I met her shortly after she came from Philadelphia. And then all of a sudden she was hanging out with the Rolling Stones. Every time you saw her, she was with [another celebrity]," Destri laughs, "but she never stopped talking to all her other friends. She was always very egalitarian. That's the word, I guess. She was a wonderful girl."

Suzanne Rodier confirms Destri's description of Gia as "egalitarian," and adds that, in her experience, the supermodel never got a "swell head." Recalls Rodier, "She was always the same Gia. I think she didn't really change. A lot of people tell stories about how outrageous she was at work, and I'm sure she was. But in her mind, she was having fun, and I always had same relationship with her. She was never different over time."

Even Rodier, however, who left New York a few years after she and Gia arrived, didn't know much about Gia's friends in New York. "I know of one friend who lived on Central Park South," she recalls, "an artist ... and I know she spent a lot of time with him. I went there with her a few times, and I believe he was a friend, but I'm sure there were a lot of people who wanted to be her friend for the wrong reasons. And she knew that. She wasn't stupid. She had a lot of street smarts and she had a good, keen eye for that kind of thing."

Even after Rodier moved out, she confirms, the former roommates stayed in touch and continued to see one another. "Throughout her career we would get together every two to

three months," Rodier says. "I would visit her, she would visit me. She seemed a little lonely, I think because she was really lost in that industry."

Gia had taken a while to work through the end of their romantic relationship, but living together as friends had turned out to be complicated for another reason: jealousy. "Gia was a jealous person," recalls Rodier. "I was jealous, too, so it made for some exciting moments. If they happened today, now that I'm older, I wouldn't say they were exciting. Once, when we were friends, I slept with one of her girlfriends, and then it was my turn to hear her jealousy. She was mad at me. She was really angry. She said her girlfriends were hers and no one else could come near them. Yes, it was a problem. We were young ... very young."

But Rodier's memories of Gia during the years of their non-romantic friendship are also sweet. "There was one time," she recounts, "when one of us came to the other one's apartment. And she said, 'Let's take a Polaroid together.' She put it on a timer, ran over, picked me up and turned me upside down. And the strange part was that, when the Polaroid came out, the image of me upside-down was clear, but her image was faded. Kind of like an omen. But she loved to pick me up and toss me around. I was like her little doll. Whenever I would see her, [the minute one or the other of us] walked in the door, I would say, 'Okay, no picking me up today.' She would promise, but she would always find [a way] to pick me up and toss me on the bed. I remember that."

7

NO FAÇADE

The incomparable Maury Hopson remembers Gia with affection and praises her professionalism. "She probably had such a zest about her that she was attractive to both men and women," Hopson says. "I would say she was lush. [She was] just extraordinary really, and she had such a soul. We all miss her very, very much. I loved her so much. We worked together a great deal, and I never had a bad experience with her. She was a wonderful person. She was completely professional, for me.

"I think she probably didn't expect to be a model, so it wasn't as though something had driven her to gain big success as a model. She wasn't a calculating person who was trying to get jobs and things like that. She wasn't thinking that she [had to get] a contract or something. I'm sure she would have loved it had that happened, but she wasn't in pursuit. She was finding herself more than she was trying to find a career.... I think it was a happy accident, and she saw through—she saw the silliness. She had a good time with it, too, and she made a lot of money. She also made a lot of friends through the business. I'm not sure she would have made the same kind of friends or been exposed to so much [in another profession]. I doubt she would have travelled as

much.... One of my favorite memories of her was when we were in Italy. We had a lovely time, and I doubt she would ever have gotten there if it weren't for modeling.

"She was very considerate of everyone working around her—the assistant, the hairdresser, the makeup artist. She was aware we were all working. There were difficulties sometimes, [but] for me, she was never a problem. There were many other problems and many other models who were problems, but for me Gia was never a problem. She was fine to work with. The only problems I can think of were the obvious ones with the drugs. Which, you know, no one can do anything about that when it's happening." For Hopson, Gia's best quality as a model was that "she never looked like a model. You never thought she was modeling. She didn't have that kind of cookie-cutter type of modeling. That's why she was so unique.

"She wasn't really an extrovert," Hopson continues. "She was even shy, I think, until she knew you, of course. But she wasn't someone who had a demonstrative personality. She was more laid back, and easy, and she didn't have any harsh qualities. If she was harsh, it was when she was harsh on herself, but to other people she was not. With others, she was very genuine and loving."

Some maintain that Gia didn't have the right character to work in fashion, but Hopson's perspective is more nuanced. "I think it depended on who she was working with," he says. "There are certain people who make us all feel like shit when you work with them, so I'm sure she was maybe more sensitive when she was working with the wrong people, who didn't respect her. She really needed to be respected [just as] everyone does. But she was so young and naïve, and I think it hurt her more when she didn't feel respected because she was basically one of the first punks. That's why she looked wonderful, too. It was when she was in her shirts and jeans with no makeup that she was very, very beautiful.... I just adored her, and so I think, if there was a problem between her and somebody else, it was the other person's fault."

Though it is true, especially toward the end of her career, that

Gia often failed to show up on set—because of drugs, it seems more than fair to say—at times her failures to appear may have had a more specific reason: the lack of respect she felt. When Gia felt respected and valued, conversely, she was unlikely to "play hooky" from a photo shoot.

Hopson recalls, for example, Gia's working relationship with Chris von Wangenheim. "I think Chris just loved the difference of her," Hopson reflects. "She was so different from so many models, and you could do anything—you could make her look slick and sleek and all that, or you could make her look rough-and-tumble.

"I'm sure she was a generous person, but she was probably also in conflict because she was making so much money. She could see other people who were maybe her own age who were not doing well, and she would think that she could give them money. Maybe there was an imbalance in her mind, that she shouldn't be making that kind of money [from] modeling when somebody else was working as a waitress and couldn't pay the rent. And so she would help them pay the rent. She just had that feeling about the imbalance of things. I'm not sure [modeling] could be blamed. It gave her the money to buy things that were not good for her, but I can't say it was her downfall. I think she probably had other demons that we don't know about that maybe led to it. Who knows?"

Hopson's happy memories of the supermodel—with her "Bugs Bunny" personality and her outsized enthusiasm for Rocky & Bullwinkle cartoons—are many. "I couldn't single out just one," he says, adding, "I love the pictures [I took] where she's leaning against a white wall, with a shirt on and jeans and looking at the camera in a very, very intimate way. No façade. She was just her."

8

GLAMAZON

Gia's transformation from tomboy to "Glamazon" left the crews on her fashion shoots literally breathless. Garren, the celebrity stylist whose clients include the biggest stars from across the globe, well remembers the moment in which Gia left behind her *"garçonne"* look and reappeared as a *femme fatale*.

"I met her around 1977 or 1978," Garren recalls. "We all started at about the same time—I mean, we were all kind of new. I'd been in the business since 1974, 1975 ... when Gia came on board. My first session with Gia was with [photographer] Gordon Munro. It was an amazing session because she was so young and so fresh. I don't think she had been in New York that long before she started shooting for American *Vogue*. She just had that ease about herself.... I mean, she'd start out with her jeans and her T-shirt and a pack of cigarettes, and then she'd get dressed. She'd just sort of sit there, have them do her hair and makeup and then, once she'd put the clothes on, there was that thing that happened. She'd look in the mirror and she would become this real woman. It was quite amazing to watch the transformation. In her head, she'd click into character, and that was just what the photographers wanted. They were hap-

py with her and, as far as I'm concerned, I really found her to be genuine. She was playful. We had some fun times together.

"The [main] thing that made her stand out is that she dressed like a boy! That was the only thing that would make you stop and say, 'Oh, that's Gia!' Very cute. Like a child. And the minute she got dressed for a photo shoot, she became a woman! I remember this one time, we were out on a beach, and they put her in a white one-piece bathing suit. Her hair was kind of cropped, and we were all gasping, 'Oh, my God! That's Liz Taylor in *Suddenly Last Summer.*'

"She just looked at the photographer and backed into the water. She was staring at him, and then she put her body into position, and all of a sudden this kid became 'glamour-beauty body.' Once a white bathing suit is wet, you can see right through it, but she knew what she was doing. She came out of the water with her hair all wet, and she was this amazing creature. She just stood there, and we were all, 'Oh my God! I can't believe this girl just did that!' She was just having fun, and she knew exactly how to show what everybody wanted! And then, once she got back to where we were, she broke back down into her boyhood. It was as though this goddess went from goddess back to tomboy again. And then she did it over, and then we all had lunch, and it was normal, you know? It wasn't crazy. There were other girls around, but she didn't really hang with the other girls. She would sort of hang by herself and just read a book or stare into space. Or go wherever her head went at times like that.

"The last time I worked with Gia was right after she came back from rehab and detoxing. She was very nervous. We had booked a session for *Glamour* with Paul Lange. We were doing color tests and makeup and close-ups with her. I knew she had just come back, and we had the kind of relationship where she knew she was safe around me. So, during the day we played around with Polaroids and with funny hats, and we were just silly and goofing around. But then, when she got in front of the camera, I said to her, 'Honey, just focus, and if you have to look away, you look away at me. I'm here for you.'

"So that was kind of hard. I mean, I really felt the hurt in her, the fear of not being able to deliver what she used to deliver. But she did deliver. She did it all through the day. At the end of the [shoot], she came and gave me a big hug and said, 'After today, I need to give you a hug because I couldn't have made it without you.' And I said, 'We just have to keep doing this, right?' and she said, 'Yeah.'

"But I was afraid for her and she just disappeared into the night. She probably went back to Philadelphia. But I had really good moments with her. We shot a lot with Arthur Elgort, a lot with Chris von Wangenheim, a lot with Irving Penn. Avedon [took] some famous photographs, [and] she worked, she really worked. I can't say she ever walked off the set when I was with her. I heard rumors about that, but when I worked with her, she was always there.

"There were moments when it was tough. Once we went on a trip with her for German *Vogue*.... In the morning we would just walk to her cabana, at eight o'clock in the morning, and she was up, she was awake, she was eating her breakfast, and we would start on her hair and makeup, and it was normal. We had a great shoot and then, at the end of the shoot, she was a little testy—not with me, but with the editor. [I wondered] 'What happened?' But I think it was just because she wanted to get home.

"She was an amazing model. People compared her to Liz Taylor, Sophia Loren, Gina Lollobrigida and all that, but Gia was special. She knew what she had to do, and she just did it. I have a lot of respect for her. I think the drugs took a toll on her. I think that's where everything went wrong, but I don't think cocaine did it. It all started going downhill when she started heroin, but all I can say about her is that she was amazing! I guess she was looking to be a legend, and I suppose it's one of those sad stories like Marilyn Monroe or any of the other fabulous-looking women [who never made it past] a certain age.

"She will go down as one of the most amazing models—this simple, low-key [girl from] Philadelphia. Low-key when she

wasn't on the set, I mean, with her jeans, her jackets, her T-shirts, high-tops, and her manners. That was Gia. I think she loved the idea of the transformation. Maybe she wanted to be an actress. I think she would have been a good actress, in the end, if she had survived. Because she could play any role, and she had this very deep, sexy voice. If she had kept going, I think that's where she would have ended up. She lived that fantasy through the camera lenses. That was the other side of her. We didn't even really think [about whether] she was a [lesbian]. It didn't matter. She was kind of asexual, really. We'd just really never experienced anyone quite like her.

"She had a body language and an attitude like James Dean.... When she came to the studio, she would be in high-top sneakers, jeans, and a belt that was extra wide. And a T-shirt and a motorcycle jacket or a short jeans jacket. She was just like that: low-key, and not like the rest of the models. And she was her cool self, very quiet. I feel that [success] happened so quickly for her. She was thrown in really fast, and the thing about Gia is that she was there to do her work, and she did her work. I didn't detect anything wrong 'til the eighties [when] she went from partying to doing cocaine. Then I saw her come in, and she'd be kind of floating."

Paradoxically, Gia probably couldn't have found a better working environment than the fashion business, which tends not to judge others for what they do in private. Romantic relationships with people of the same gender, then, wouldn't necessarily have provided a pretext for discrimination. At the same time, it's plausible to imagine that Gia might have encountered rejection, whether it was manifest or subtle, from individuals whose minds were less open.

On that point, Garren reflects, "I think it's like when gay children are in school and they are sort of outcasts, or she might have been a tomboy and classified as kind of an outcast, and then she strolled into this world of beauty, and everybody around her was thinking about beauty and fashion, and she was just this cool kid! I don't think she had any self-destructiveness. I mean,

everybody has some self-destructiveness, but I think she was just vulnerable and was trying to find her way in a big city. Going to Europe, going to Rome—it all happened so quickly. When things happen quickly to someone like her, who is so young, especially in those days, you don't know how to handle it. Or you try to handle it the best you can. She really never got very close to anyone. We all tried. We all wanted her to win this battle, but I guess she just got further into it. Like a downward spiral.... Once you cross into the heroin world, you've gone so far that it really takes a lot to get you out. You have to have the right resources to help you through. If the resources had been there in those days ... but in that time frame there wasn't enough to keep her away from [drugs] or help her get her self-esteem back. It was easier for her to float away, I guess.

"I have pictures from the last shoot we did. We were goofing round, and she dressed me up and told me to sit in front of the camera and be goofy and do this or do that. I remember she was laughing. I knew Gia was the real Gia that day. She was just like the person I met way in the beginning, and we had a really good time. I knew she was afraid, and I think the camera saw it as well."

Though Garren was one of the few people in whom Gia could safely confide, the supermodel remained mostly closed, even with him. She never spoke about her family. "She told me she came from Philadelphia," Garren remembers, "and I said, 'I'm from Buffalo.' And she said, 'Well, I guess you know the drill,' and we laughed and she said, 'At least we got out,' and that was it."

During one photo shoot, however, Gia told Garren about the anxiety she felt—that she wouldn't be able to finish the session, that she didn't think she had it in her to give what the shoot needed. Garren recalls that Gia had just come back from rehab. "When she saw me, she hugged me," he says. "She told me, 'I don't think I can do it today,' and I said, 'Yes, you can! You have us here. You have me here. You can do this if you want, but if you don't, then you should just go home or call your agent.' And she said, 'No. I'm gonna do it. I can do it.' So that was the only time [she opened

up to me]. Other times she never really talked about anything. She was just very quiet.... I was like a father figure with her, I guess. She never gave me troubles. She never, never acted up when she was on the set with us. She was just professional. Yes, she was special! She was alone! But, you know, she did her job."

Garren's colleague, Gad Cohen, adds, "I worked with her on different magazine shoots, but I never really socialized with Gia or anything like that." Cohen recalls the last time he worked with Gia, which was a "shoot for *Cosmopolitan* in January 1983, part [of a series on] the ten most beautiful girls at the time. We did the shoot with a different photographer, [Jacques] Silberstein. There was Gia, there was Bitten and different [models] of that era. There were a lot of other girls working.... To be honest, she was very easy to work with.... [On the day of the *Cosmopolitan* shoot], she was very quiet. That day was very good. She was actually the last [model] of the day.... She was very ... rock-n-roll, with her motorcycle jacket and jeans, very casual, and then all of a sudden you could make her look like a glamour girl.... As a model, she was amazing. Because she came in looking great, very simple and low-key, and then she would always try to [establish] herself well in front of the camera. And no matter who worked with her, she would be ... amazing, the way she posed in the light. She was very *collaborative*, and I *never* had any problems."

Hairstylist Anthony DeMay recalls meeting Gia "in a gay nightclub in Philadelphia around 1977," he says. "She looked like a really cute boy. She had a short wedge but wore jeans and a white men's Oxford cloth shirts. She was shy, but at the time everyone was doing Quaaludes, better known as 714s, so she was friendly, but I knew she wouldn't remember me in the morning. As a model, she was really an introvert and never really got along with other girls unless they also had a reputation for partying. But when Gia got in front of the camera, it was perfection; she turned into a 'Glamazon' right before your eyes. She made everyone's work look *better* than it was, whether it was hair, makeup, clothes, photographs. She was the only model that gave me

goosebumps watching her work. But once the shoot was finished she withdrew into her cocoon.

"The first time I got to work with Gia was April of 1982. It was for *Linea Italia* [a now-defunct Italian fashion magazine]. Having [seen] her in every magazine possible, I was shocked at how plain and ordinary she seemed. She was also really quiet and unassuming, and quite guarded. Her reputation was on the downward spiral, and people would bet on whether she would show up or not, or whether she would like the day's wardrobe— there were many stories around about how she would walk out if she didn't like the clothes. I was good friends with Nancy [Gia's aunt] and her friend, Joanne, who use to cut Gia's hair in Philadelphia, so I was able to make the Philadelphia connection. That put her at ease in my chair. I knew she could be pretty rough if she didn't like the hair you did on her.

"Her goal [had been] to do the cover of American *Vogue* [which she did in August of 1980], so I think everything [after that] was kind of a bore for her. Most of the girls I'd worked with seemed to be excited about the day's shoot—whether they were or not, it was just good business sense [to appear to be]. I've always felt she hated modeling, but did it, *begrudgingly*, for the money and for her mother. Later in the year we were doing a shoot for American *Vogue*, and I noticed Gia using the make-up artist's concealer on the tops of her hands. It turns out she had lesions from using a needle repeatedly to shoot heroin. The photographer happened to be a woman who really liked Gia and respected her. But Gia was worried about her hands, so the photographer took pains to make sure the abscesses wouldn't show. I remember how worried Gia was that other photographers would see [them] and not work with her. As unusual, however, as soon as the photographer started shooting, she turned into the *sexiest* and most gorgeous woman imaginable.

"But I don't think Gia enjoyed modeling at all. I think modeling ultimately became a noose around her neck. Ultimately, I feel Gia was modeling to get the money to feed her drug habit. I

knew she could be spiteful if she didn't like the hairstyle or make-up and wardrobe. She was known to jump in a pool, if [there was one on] location, to make the stylist have to get her back in shape to continue the shoot. There were days when she would come to a booking and not like the clothes, and so she would walk out. At the point when I was working with her, between 1982 and 1984, you could tell that all her initial joy in modeling had disappeared. She was extremely introverted by then because she knew that most people were talking about her in a bad way.

"On one advertising shoot we did, there were two other models booked. Normally, Gia would [have ignored them], but this time one of the models was Bitten Knudsen whose own career had suffered the same as Gia's. So they were actually very friendly, but Gia was looking really sad. I managed to put a smile on her face by telling her I had made her the prettiest of the three models that day. Once the photographer started shooting, she came alive and [that] was the Gia we all remembered.

"The first time I worked with Gia she seemed normal to me, [if] a little shy. By 1983, we were doing American *Vogue* with Vera Wang as the fashion editor. The first thing Gia did, besides being an hour late, was to walk out onto a fourth-floor fire escape. We all were speechless, and when she came back, she looked really pale and pasty. She was really down, and the photographer had to convince her she looked good.... As always, once the camera started clicking, Gia was incredible. All the tentativeness had disappeared and she became the most gorgeous, sexiest woman alive."

Her cover-girl beauty, which seemed to run counter to every stereotype, meant that Gia had to push back against preconceptions. "I don't think Gia had any issues with her sexuality," De May says. "If anything, it was the opposite. She had to force people to believe she was a lesbian. It wasn't like she purposely had to act straight. Just looking at her, you would never in a million years believe she was gay. The funniest thing I remember Gia saying was that she couldn't understand why everyone thought she was so sexy. 'Don't they know I'm rotten in bed?' she asked."

9

BORN THIS WAY

The people who knew Gia most intimately recall that Gia lived her sexuality openly, neither hiding who she was nor confining her nature by applying arbitrary labels to it. Gia was, as Rodier put it, "just who she was."

Gia's authentic personality, in other words, which came through in her every action and gesture, expressed itself in the most natural way possible: She followed her instinctual attraction for the man or woman she happened to feel drawn toward. At the same time, Gia smashed stereotypes—both gender stereotypes and popular preconceptions of beautiful women in the glamorous world of high-fashion modeling. In fact, to the extent that female supermodels are often venerated as heterosexual sex symbols, a kind of false connection is sometimes drawn between the image that appears in the glossy pages of a magazine and (presumed) reality. That is hardly surprising, but in Gia's case, the projection of fantasy onto real life became glaring. Even today, some skeptics have difficulty accepting that Gia's intimate relationships were an expression of her genuine self.

Two things nonetheless remain clear: First, Gia was a private person who, if she was prone to self-analysis, confided such

thoughts to very few other people; and, second, given that Gia cannot now speak for herself, no one is in a position to say with complete certainty how she would describe herself or her relationships. What we do have are the recollections of those who knew her best.

In Rodier's view, "Gia definitely loved women more than men, [and] I'm not just talking about my relationship with her, but about her relationships with other women that I knew of. She was madly in love with women, but she slept with men—very good-looking men."

Sasha Borodulin confirms that Gia "could go both ways," though he believes she preferred women. "Gia liked sex," he says, "but she told me more than once that making love with a guy made her feel strange. She'd sleep with any guy she found attractive, but the point was, she didn't want any kind of 'intrusion' in her body. That's what sex was for her. If it was a question of men vs. women, she'd probably have taken the woman, but she found men attractive, even though she was less interested in the idea of having sex with them.... Sex was very important for her from a psychological point of view. She was [also] terrified of sexually-transmitted diseases, and she thought any guy she slept with was going to pass something on to her. For some reason, the same thought didn't enter her mind when she slept with women."

Her friend, Rob Fay, maintains that Gia "did struggle with [people's reactions to her sexuality] because it was difficult for everyone else to accept. I don't think she had any problem exhibiting it, but people didn't always take her [relationships with women] seriously. One of the most beautiful girls in the world was gay! I didn't have a problem with it, but there was a lot of rejection ... from mainstream society."

For his part, Bob Menna avoids labels altogether. "I would prefer to say she enjoyed women," he says. While she never said 'You know I'm gay,' she also didn't hide it. It was obvious. She was almost like a guy. If she saw a woman she liked, she might throw me a look that would say 'What do you think?' and I

would give her the thumbs up or down, and that might be the extent of it. It didn't happen that often, but it never happened with respect to a guy, nor did I ever see her looking lustily at a guy. Gia definitely had some masculine traits ... but I found that very appealing. She would never worry about having her hair messed up. She didn't spend hours at the mirror. She was for sure tomboyish. However, that juxtaposition with her beauty was a large part of her appeal to me. Don't get me wrong. I understand that most women [are concerned about] how they look, and I accept that as a part of [their being] women. I sure appreciate it. It's just that [the absence of that] made things so easy and relaxed [with Gia]."

Gia's physical beauty, more often than not, was enough by itself to make the object of her affection surrender. There was a certain delicate, androgynous "something" in Gia that everyone, including straight men and women, immediately noticed. Celebrity makeup artist, Lisa Jouet, recalls, "I worked for a very long time with one of the most famous hairdressers in the world, John Sahag. "I was John's personal assistant and his executive assistant, and then he opened up his first salon, and I managed the salon. I worked with him [during] the most important part of his life and, because of that relationship, I got to meet and hear stories about many people. I didn't know Gia well, but I would say that I thought Gia was incredibly beautiful. I was always attracted to women that had a very androgynous look, and she did. She was big, she was strong, she could look feminine or she could look butch, and I thought it was very hot!

"There's a picture of a woman that Helmut Newton shot—a model I was very friendly with, Vibeke Knudsen—on a street in Paris [the photo is Newton's famous *Rue Aubriot*]. 'Vibe' is wearing a tuxedo, and her hair is pulled back. She's standing with a naked woman, and she is like a street lamp. It is very, very sexual, a very strong suggestion of two women in love, [and] one is masculine and the other one is feminine. That is kind of the feeling I got from Gia, that those polarities lived inside her, the feminine

and the masculine. If you take a look at that picture, what I'm trying to say may resonate."

In Suzanne Rodier's experience, the duality of feminine and masculine, which seemed to find a perfect harmony in Gia, "was natural for her.... Gia was very comfortable being a tomboy. She had no desire to be a prissy girl. But in front of the camera, made-up and dressed, she could take on that persona. Still, I don't think there was any question in her mind about what she was or how she [preferred] to dress and act."

Gia wasn't fond of being pursued. On the other hand, when she set her cap for someone she liked, especially if it was a woman, she'd go right up to her and make overtures. There might have been just a touch of passionate insistence involved, but there was certainly no hand-wringing. At times, she was so impetuous that the object of her affections was left dumbfounded. Gia, undaunted by social conditioning, wasn't interested in holding back the powerful impulses she experienced. Rather, she let her instincts guide her.

"If she met a woman and she wanted to be with her, she would immediately go up to her and tell her," Rodier said. "So I'm sure there were many straight women who were taken aback by that because she never held back."

"Never held back" is one way to sum up Gia's expansive personality, her passionate attractions to both men and women, and the freedom she felt in expressing her sexuality. However Gia might have described her desire for physical and emotional connection with others, her chameleon-like ability to "play" freely with gender roles, or her most significant intimate relationships—assuming she had ever chosen to speak openly on such issues—we can draw one clear conclusion. In every aspect of her life, to use an expression that has become popular in recent years, Gia was "born this way."

10

SMALL-TOWN GIRL IN THE BIG CITY

Female supermodels in the seventies and eighties possessed an unparalleled beauty. Even on their worst days, without makeup and with circles under their eyes that testified to the previous night's carousing, they could still stop traffic with a sexy stroll down the street. There was very little of the digital trickery that today makes it so easy to compensate for a model's minor physical flaws (presuming she has any), and the natural beauty of female models in those years consequently seems even more striking. The supermodels of those decades were, in addition, markedly different from one another: There was no room for copycats. What agencies and magazines wanted was a look that stood out among the masses of commercial models. Brunettes were strongly coming into their own in the fashion industry toward the end of the seventies, but they weren't replacing the homespun look of American blondes or the chilly Amazons of Northern Europe. If, for example, one of the main characteristics of Gia's "Mediterranean" look was her accentuated sensuality, beautiful blondes never stopped captivating agents, editors, and the public, and each blonde supermodel who broke through did so because of aspects of her look or her approach that set

her above the rest. The Texas-born model, Kelly Emberg, for example, with her delicate features and Princess Grace deportment, seemed to have stepped directly out of the pages of a fairy tale.

Still, one of Gia's "signatures" as a model was her ability to use her expressive face as a tool of communication. Her ability to transfix with a glance, however, could sometimes turn into a trap for those who crossed her path. The heterosexual male models who worked with her knew that all too well. They weren't the only ones, however. Even people who had never worked side by side with Gia nurtured more-or-less secret crushes on her.

During the time that Gia was working with Wilhelmina Models, the agency was located on 37th Street, between 5th and Madison. Bradley Burlingame, one of the agency's few male models, often crossed paths with Gia there between 1979 and 1980. "Of course, everybody knew about her beauty!" Burlingame says. "Of course I was attracted to that! It's so strange to talk about, because it was so long ago.... I wouldn't describe myself as a very close friend, but there weren't a lot of people [in the agency]—maybe fifty or sixty girls and a small number of boys. But because it was so small, it was almost like family.... [We] were young! [We] would hang out there! I always wanted to take Gia out on a date. She was a very smart girl, very quick, and she [had] a dose of street smarts as well. I was always [asking her to go out], and she would [just] look at me," Burlingame recalls with a laugh.

"Maybe I was more attracted to her than she was attracted to me. We thought about making plans, maybe going for a walk in Central Park, but she was so busy at that time. It was very difficult [to set a date]. When you're young, you try to make yourself available [for] bookings, especially the girls.... Or we would make plans, but she ended up canceling. But I would always talk with her because I had a big crush on her. It was and is a warm feeling to think about."

Though Burlingame and Gia never worked together on a photo shoot, he was able to observe that Gia had many charming qualities beyond her physical beauty. "She was a wonderful

girl," Burlingame affirms, "funny and smart. My [main] memory of her is that I had a big crush on her. I was so badly in love. We talked mostly about the business ... not so much about personal things. I was trying to [get] a date with her, but I liked her spirit.

"I was a kid from California ... [and I would] run into these girls from all over the country.... I have memories of people at Wilhemina in those days who had bigger careers. They weren't just models. You might not have heard about it, but Whitney Houston was a model and was represented by [Wilhemina]. She was young, and she went off to an amazing career!

"Gia was a small-town girl in the big city, but ... she had a big-city mentality and street smarts, and it isn't just her beauty I was attracted to. I'm sure all the people you've talked to [say that], but it was her *brain* to me that was *fascinating*. It's sad that she died because it makes you wonder what would have happened with her life, beyond her beauty. I think she could have turned into a successful businesswoman and followed the path that other models have through the years.... Gia could sense things, and she would know if you were bullshitting her. The other girls were very, very naïve, but not her. I think she got trapped in other things, but she wasn't naïve.

The atmosphere in the agency, especially for a young model just starting out, could be hectic, Burlingame recalls, but also convivial and safe. "The [bookers] would want you to report in there [so they could] review your portfolio and [tell you] if you needed new pictures. You don't think of it as a business, but it is a business. They were coaching you: 'This is what you need to do next,' 'This is the photographer [you should see].' Especially in the early days, when you are developing your book. Sometimes you would go in to pick up your check, but you would go into the agency several times a week. It was a place to hang out.... You would just go there to hang out [socially] in the middle of the day, and you would get invited to parties all the time. I'm sure [it was] the same thing at other agencies like Ford or Elite or whatever. [The agency's office] was like a second home, especially be-

cause you were young. You would just go there and wait for your next interview—you'd have two, three interviews set up, and you wouldn't go back to your apartment. The bookers and all the people who worked there became your friends. It was definitely a lifestyle! With all the other stuff going on, it was a safe place to be. I became close friends with Wilhelmina and her husband, Bruce. They would take young girls and let them live at their house, when they first [arrived]. They were family. They took me to a jazz festival because I was into jazz, and [I would] hang out with Wilhelmina and her husband. Amazing memories.... In those days, sex was pretty open until 1982 when AIDS came out. That changed everything."

Lisa Jouet, executive assistant and, later, salon manager for John Sahag, one of the industry's most legendary hairstylists, recalls that Sahag also tried to help provide Gia a sense of normalcy in the midst of her hectic days. "I know John was very fond of her," Jouet says. "He felt protective toward her. We would sit around and drink wine and eat Lebanese food and laugh. I mean I was twenty-two at the time, so I was intimidated by everything and by anyone I met who was exotic and unusual.... Up in [Sahag's] loft, I didn't see them in designer clothes. I saw them all without makeup. I saw them when they came up and took their shoes off. You know, they would put their feet up on the table and take a nap in the afternoon."

To Jouet, Gia seemed fairly introverted. "She was really quiet," Jouet says. "I never saw her high, so I don't know how she acted when she was on drugs, but ... I remember her being very laid back.... John had a way of bringing something out in people, so he was able to make her relax.... This is very important because I got the feeling that, on the one hand, she knew who she was and, on the other, that she wasn't comfortable in her skin."

Jouet declines to comment on whether Gia was happy in her profession, but she did observe that Gia "had a great deal of vulnerability, this sense of abandonment.... She seemed to be searching for something far more important than being a model.

Obviously, if she wanted to be a model, she would have taken better care of her career. But what she really wanted, I think, was to find love and peace inside of herself.... She didn't have her own inner anchor, and I think she was trying to find an anchor—something that grounded her."

11

TOP MODELS ONLY

The effusive stylist, Shelley Promisel, who had also spent time as a model, holds back little in remembering Gia and her experience in the fashion industry at the end of the seventies. Promisel and Gia, in fact, were nearly the same age. "I was shooting a lot in upstate New York," Promisel recalls. "I always loved working there, and I brought Gia with me many times. I did have fun with her, and I always compared her to Madonna. To me they were so much the same type, in a weird way. I worked with her quite a lot and I really liked her.

"One thing about Gia that was different from all the other models: When she walked in, she was beautiful, but she was real. She wasn't like one of these girls who tried to be beautiful. With her, you would think, 'She is drop-dead gorgeous!' She walked in with 'naturalesse.' She'd be smoking a cigarette, and you'd [say to yourself], 'Really? This is Gia?' She could take any piece of clothing and wear it—even a paper bag—and she would look great.

"I knew about the drugs, and everybody was doing [them], but it wasn't heroin—it was coke. Everybody was saying, 'You know, Gia is a druggie,' and I would say, 'Ninety percent of the girls in the dressing room would do [the same thing].' But they

were nagging on Gia. [The attitude was], do it when no one can see you, so you don't get caught. But the thing about Gia [was], she would be really late, and after a while she would say, 'Michelle, I'm exhausted. I want to go home.' She looked tired. So I'd say, 'Fine. Let's get the job done in a hurry and let's get the hell out of here. But I have to say she really worked hard, and she always wanted to work. She wasn't like the other girls who wanted to make twenty thousand dollars and get out and that's it. Whether her goal was work or money, I don't really know because I didn't know her demons.

"We would hang out after work and go out and have fun but, honestly, I didn't know about her extensive history of being a drug addict. I truly didn't know how bad she was.... I don't know at what point she started using drugs. [When she came to] a shoot, she was definitely not drugged-up. In my mind, she wasn't doing drugs, but then again ... with someone like Gia, I could never tell. She was always herself when she arrived. I [worked with] a model [who] was stoned out and could not perform. When I compare Gia to that model, Gia was never like that.

"Now I remember she was from Philly, but she seemed very New York—almost like she was from Brooklyn. The thing was, I [had been] a model at the same age [so] we would hang out, and I was more like a friend, a confidant, a therapist, a mother ... you know, when you're in the dressing room, you talk. But I remember Gia didn't come in with that attitude of 'I'm here' like the other girls. They had attitude. I'd reply, 'Yeah, I'm here, too.' I thought [privately], 'I'm more valuable for the shoot than you are because you're a dime a dozen.'

"When Gia [walked in], you could just feel that warmth. She was funny, always made you laugh. The interesting thing was, if there was some guy, she could seduce him in a minute. She could be a seductress—different from the other girls, and that's prob-ably why some of them didn't like her. She had this way about her. I thought I was good, but she was a killer! She just had this way [of bringing] everybody into her world for work. She'd say,

'Listen I want to get out of here. I want to go drinking. I want to go partying,' but when she was working, compared to the others, she always took over like a leader. Like a tough kid from New York: Let's get in and get the job done. When people worried or moaned like some of the other girls, she never put up with it. Her attitude was, 'Come on, stop complaining. Let's just shoot, get it done, and get out of here.' So I remember that she was funny and hardworking and [that she] always got the job done! I could always relate to that. I was there for a job, we were all there together, [being] very highly paid, exaggeratedly paid.

"A lot of the work I did with Gia was catalogue. At that point in my career, I thought, if I'm not doing high-fashion jobs, hey, this pays the bills. At one point I was doing Clairol's top commercial and fashion ads. So if it was slow, I'd do my catalogue job, and I'd call the agency and ask, 'Who's available? Top models only. Tell them it's for me.' Or I'd call the booker for Willy [the Wilhelmina agency], and she'd say 'I have this one and this one and this one,' and I'd decide who I wanted to work with. When Gia's name came up, I always took her.

"When you hear [people talk] about her professionalism, it's weird. You know: 'She was sleeping. She was late. She's always late.' But ninety percent of the girls were late. You knew who was late. You knew who would be on time. You knew who would give 100%. You knew what attitude they [would have] as they walked in the door. But I didn't really care. I would say, 'Screw you all.' I could get the job done anyway and better than them. When I was working with Gia, I [recall] her as one of the girls in the background, and yet she [had] the best personality of all. [I don't know] whether she was in it for the money. Definitely not for the fame—she wasn't a 'fame whore,' meaning she didn't come because she wanted to be 'seen' or become famous or wanted everybody to notice her. I think she was thankful.

"The [reason I say Gia] reminded me of Madonna is that Madonna was also somebody who made herself, and that is exactly what Gia did. Gia created her own image. Created her own

beauty.... There are certain girls who demand attention and get people to notice them, and they are like that because everybody believes they're beautiful, but they're just full of themselves. Those girls were born beautiful. The way I see it, Gia wasn't—but Gia was a real beauty. She invented herself. She made people believe she was beautiful. She was unbelievably sexy and seductive. She was nice and funny. I never had a problem with her! I related to her really well.

"I loved her because she wouldn't give a shit about the way she would carry herself, and yet she was a natural: chewing gum, smoking, jeans, boots, a man's shirt—and she would steal the show. That [was] the difference with her. We all knew she would turn a piece of crap into a stunning beauty, and she worked it! [Other] girls were beautiful, but they couldn't work the garments, especially for catalogue. Catalogue [work] wasn't the most impressive, or anything you would want to put on your [resume], but it paid the daily bills. Catalogue supplemented the magazine industry, and we went to gorgeous locations. In commercials, you make more money, and eventually we all left catalogue for commercials.

"The way she would dress made you think she probably liked girls. Yet she would have every man drooling over her. Give her a few minutes, and they were seduced by her. They were just mesmerized, falling all over her. I remember once doing this test photo shoot. There was Barry Kaufman—he was the only Jewish model in the business. He was totally mesmerized by her, and she could make him fall in love just with her eyes. But she wasn't erotically interested because, as we now know, she didn't care about men. Still, she could probably get any man [better] than any straight women. She didn't come across as gay. She wasn't 'dykey.' It was unusual in those days, but we didn't care about gay or straight when she modeled with me. All these girls were all so feminine and wanted to be attractive, but not Gia.

"I think she would have been very happy doing anything. Modeling was just something [to do]. I don't really know how it all start-

ed, but I know she didn't search it out.... I guarantee you she didn't take twenty pictures into an agent and say, 'I want to be a model.'"

Promisel also recalls that Gia could be a "tough bitch" if she didn't like someone. "She wouldn't take shit from anybody, that much I would say!" Promisel laughs. She recalls one example in particular. "We were doing this awful shoot with a French photographer, and we were waiting for her because we had to drive three hours upstate. I remember Gia didn't show up, and I called Willy [the Wilhelmina agency], and they said, 'She's coming, she's coming. She got in late from a shoot—she's coming.' I was losing my patience, and they said, 'Do you want somebody else?' and I said, 'No.' The photographer was dead-set on her. So I called her agent and asked, 'Can I have her home address?' They didn't want to, and they said, 'She's packing and getting ready,' and I said, 'No, she's not packing.' So finally they gave me her home address, and I went to her house and rang the bell. She came downstairs, looking dead, and said, 'I'm hungover. I'm exhausted. I don't know how much you would get from me. I want to come, but I'm sorry I'm like this.' She was always very apologetic.

"So I said, 'Here's the deal. You'll have a great night's sleep at the hotel. So let's go, [get some] sleep, and let's just see what happens in the morning.' She said, 'Great.' I knew she would agree to it, but I didn't know as [I do] now, that she was at 'that point.' So we went with the [other] models, and I saw her dozing off—now I know what it was, but not then; I thought she was hungover or tired. [When we arrived], I told her to go [to bed], and the others said, 'Why does she get to sleep?' 'Because I said so,' I said.

"The last time I saw her it was for a shoot with a French photographer. I think it was 1983 or 1984. We were shooting for a magazine, and it was very difficult. It was a whole trick to get her [to] work, but we needed her because we had three girls and her. We did all we could with the other three, and [the photographer] didn't want the responsibility [of getting] Gia on set. So we called Gia's booker, and she said, 'She's OK.' [So] she came on shoot and did a perfect job anyway. And that was the last

time I saw her. If it had been anyone else, she would have been out of business—but she was Gia. During that time, [whenever] I would call her, she'd come and she would do the job. Like I said, she was real!

"I always had this weird desire to protect her, and here she was, the toughest chick around! But when she was vulnerable ... people wanted to protect her. I think that was our downfall. When we saw [the vulnerability], we had the desire to protect her, but we didn't see—or didn't want to see—what was really happening. She was probably a great actress because she was able to cover it up! And maybe in her own way she was telling me what was happening. I listened, but I guess I didn't listen that well. I just didn't see the signs."

Nor had Promisel noticed symptoms of depression in Gia. "I believe she was looking for something, and she fell into modeling searching for whatever that was," Promisel says, "but no depression. If she was depressed, I never saw it. She was always happy, outgoing, and funny. She would always pull pranks on you, even though there were times when you didn't know if she was serious. She would sometime fake-act so she could pull a prank on you."

"Even in the dressing room, we would all laugh about the clothes she would have to put on sometimes—I mean, they were horrible. We'd say, 'Who cares? You're getting paid, and I'm getting paid to make it look good.' She had a great body, and sometimes she would have to be exaggeratedly sexy and very feminine. That wasn't what she wanted to do, but she could [fake] it and [then] crack up after the shoot. She worked it! I'd wait outside her dressing room [when] she had to wear crappy stuff, and she'd say, 'Oh, my God. Do I have to wear this?' I'd say, 'Just put the damn thing on.' And then she always looked great! I remember she always made me laugh. She was so real. She was funny, and she was honest ... too honest."

In the highly competitive atmosphere of professional modeling, interpersonal rivalries and jealousy couldn't help but be one of the realities of the workplace, and Promisel had the sense that

Gia "wasn't liked, especially by the Europeans, the Swedish girls, because they were cold. When Gia walked into a room with other models, they would say, 'She's a model?' I'm sure they thought Gia wasn't up to their caliber, but she was better than all of them. I know when Gia was late, they would be really pissed because they thought she was like a prima donna and liked being the last one to make the best entrance. But [really] she couldn't give a fuck. When Gia was late she was late because she was late!"

When Gia finally walked in, Promisel recalls, she'd disarm any complaints with an air of "'Whatever. I'm here. Let's get started.' The other girls wanted apologies from her. And [her attitude would be], 'I'm not giving you an apology! This is who I am. I'm late? What else is new? Yeah, I'm late. Let's go! Let's move!'

"I didn't pay much attention to that because ... all these models [are] full of insecurities and hostility [toward] the other models, [as if] each woman wanted to kill the others. When Kim Alexis and Carol Alt and Kelly Emberg became superstars, [there were people who] would say, 'Why is she a superstar? I'm the real superstar!' We had to deal with all of these personalities and insecurities. At the beginning of my career, I didn't even have an agent. I did it all by myself. I took what I wanted, when I wanted. [At a certain point] I said, 'I'm done with that. I'm going for the money,' and I started working behind the camera and not in front. I chose who I wanted to work with, and Gia was one of my favorites. I didn't care how famous or big they were. I worked with who I got along with the best."

Promisel is equally candid in reflecting on the help and support that members of the fashion industry offered (or failed to offer) to Gia when she was in trouble. She says, "I think everybody was into their own careers. It's not that people weren't protecting or taking care of her. If I had known, I would have tried to help her. I'm not sure what people knew exactly, or what the fashion industry knew or not. I think she had her own demons. I'm not sure [whether] the industry was responsible. I think she met people who opened doors [to drugs], and they were wealthy,

but I think she would have done it anyway. I mean, you would go to parties, right? And people offered drugs to you. At Studio 54, up in the balcony, I always had free drugs [because] they just gave them to you. I could have had free drugs every day of my life, but I chose not to. No matter what industry you were in, drugs were around and available and they all did it. So if she was going to do it, she was going to do it anyway. When I look back, I think she probably had some self-destructive behaviors. I think she self-destructed. I don't know why. Maybe she had issues in her early childhood or demons she never faced, but I don't think the fashion business helped her [use drugs]. I don't believe any business could have had much control over [her] money or willpower!"

12

VOGUE IS MY BABY

The Los Angeles-born model, Eva Voorhees, built a reputation in the seventies and eighties as one of the industry's most alluring female figures. She met Gia in early 1979, on a *Vogue* shoot, not long after Voorhees had arrived in New York. The two of them subsequently worked extensively together for *Vogue* and *Harper's Bazaar*, among other projects, modeling for such superstar photographers as Alex Chatelain, Andrea Blanch, Richard Avedon, and Denis Piel.

During their first job together, Voorhees recalls thinking that Gia was "a cute little kid. She was flopping and popping around the studio, sticking straws in the makeup artist's legs [Joey Mills]. She was just adorable. Nobody acted like that. Nobody acted completely off-the-wall and still did her job. She was always being goofy when everyone was quiet, making them laugh. She's probably the only one who had that attitude, even though everyone else was probably thinking, 'This girl is kind of a nut.' But initially she was happy all the time. She was having the time of her life. She enjoyed her work."

Once, when the two models had traveled to Jackson Hole, Wyoming, for a photo shoot, Voorhees went to Gia's hotel room,

where she found Gia writing postcards. "She was writing one to her booker," Voorhees recalls—a postcard with an image of the famous Snake River on it—"and she wrote, 'Having a wonderful time. Wish you were here at the bottom of that.' Can you imagine being eighteen and having [that kind of] sarcasm?"

Gia's antics continued as the two prepared to fly back to New York together after the shoot. Laughing, Voorhees remembers a scene at the airport. "In the old times before 9/11," she says, "you would just walk in with your bags and stuff and put them on the conveyer belt. So Gia [put her bags down] and told the security guard she had a gun in her bag. I was, like, 'No! You don't do that!' She thought it was funniest thing in the world. She was laughing the whole time. Then they started following us to the terminal! [At the gate] there was a man sitting there reading *Cosmopolitan*. She was on the cover of it, and she told him, 'That's me on the cover.' The guy was like, 'Yeah, right.' [In the airport], she was dressed like a little boy," Voorhees laughs. "He didn't believe her at all. That was Gia."

At work, Voorhees says Gia was "the one who was always smiling at the crew, always laughing, even during the shoots. She was always giggling and having a good time.... I remember a young girl who never seemed down. There was so much good about her."

From what Voorhees observed, Gia "loved being a model. She was amazing! While she was working, she was a real performer and seemed to enjoy it. She was a natural, and the camera loved her. One thing that [stands out is that] she was so completely *loyal* to *Vogue*. She knew *Vogue* was the magazine that gave her everything, and she'd call it 'her baby.' And I used to think, *What are you talking about?* Back in those days, *Vogue* was paying ninety dollars a day, but she'd say, '*Vogue* is my baby, and I'd rather work for them than anybody else.'"

Voorhees experienced Gia as someone with a "great heart. If you were her friend she would hang out and joke a lot with you. She was really funny." And, though Voorhees saw Gia as a

jokester and morale-booster, she is well aware that some remember Gia as a troubled loner. "I didn't assume Gia had everything figured out," she says. "I didn't know who I was until I was in my 20s.... What kind of responsibility level do you think we had at that age? I think the expectations are set way too high. We were all young girls, falling into that business, and ... maybe she was trying to find out who she was. I have *never* seen one model walk into this business completely confident and knowing [exactly] what she wanted in her life. You kind of figure that out as you go along."

Typically, Voorhees recalls, models would simply be told "where to go for the booking, when to be there, what to do, and then, [when we had] off time, you were trying to figure out what to do with this enormous amount of money that had just been thrown at you. And maybe, maybe, maybe you could find someone who wasn't just trying to use you for who you were or the way you looked or how much money you made. It's a massive undertaking to find people who are real in that business...."

"[Modeling] is a difficult job because you're put on a pedestal but you just want to be appreciated for who you are. Overall, what transpired with Gia [is that she] was pretty much *ostracized* and, because of that, I have a desire to protect her. I think she was a lonely girl, and she wanted someone to love her. When things got out of hand, it wasn't the kind of business that takes people aside [to try to help]. As long as they can make money, they will continue to use you, and agents push the models to work.

"There were so many things that worked against her. Being sweet and kind and sensitive, she wasn't hardened enough to continue to pursue it. I mean, to continue without any guidance. I don't know if she had anyone to turn to...." The memory is so overwhelming that Voorhees begins to weep. "I think she tried," she says, "and they turned their back on her. It's just a shame there wasn't anybody that reached out to her. I have a lot of respect for who she was.... I wish I could have done more for her. She was so young and had nowhere to turn her head to—or better yet, her heart."

13

VALENTINO'S QUEEN
OF THE CATWALK

Another of the bright lights with whom Gia worked frequently during her brief, intense time in the fashion industry was the makeup guru, Joey Mills. One of the first African-American makeup artists in fashion, Mills created iconic looks for some 2,000 magazine covers during his career. Like Gia, Mills also hailed from Philadelphia. "For a time, I think I worked with her probably every week," Mills recalls. "We were always so busy during shoots or runs, but I worked a lot with her, from the moment she started until she died. We first did *Mademoiselle* together, and my first [thought] was [just as it was with every new model], what movie star can I make her look like? Her look to me was a combination of Ava Gardner and Liz Taylor. We became good friends and would go to the Village together, even though we were years apart. [Although] I was older, we were both from Philadelphia, so I would say there was a [personal] connection. She had a wonderful 'offbeat' personality, very down-to-earth, a little eccentric. When I remember her, I remember her wearing a pair of Wrangler jeans [with] a pack of cigarettes in the back pocket, and a man's white T-shirt. That was her look. I remember

her being very low-key but yet noticeable, simple but eccentric. She was beautiful, and she was a fun girl to hang with—always cheerful and always joking, especially if she liked you, and I guess she liked me. The feeling I had was that she was a natural, and she was a joy to hang with. Now I know she wasn't like that with everyone, but with me she [was]. She was a great girl to go out and laugh and have fun. She knew how to enjoy herself."

Among the many projects he worked on with Gia, Mills remains especially struck by a shoot in Italy. "We did Valentino in Rome,' Mills recalls. "It was incredible, but Valentino thought she was really beautiful and wanted her to do runway, and her reaction was, 'I never do runway. I don't know how to do runway!' And Valentino said, 'With great makeup and hair, all you have to do is walk with an attitude!' And she was the star of the show amongst all these [other famous models]. She was amazing! We had such fun. The last time we worked together was either there [in Rome] or the cover for *Cosmopolitan*."

There can be no doubt that Gia used her talent as a model to create extraordinary, everlasting images, but that fact can—and has—led some to confuse Gia's professional success with the question of how much pleasure and fulfilment she experienced in the work she did. Mills is one of the many who believes Gia "wanted to be something else." He continues, "She never really got into [modeling]. She never got into the phoniness of the fashion model industry. Come on, this girl did covers for *Mademoiselle*, *Glamour*, *Vogue*, *Cosmopolitan*. What else is there? And she didn't care at all about what she was doing. That's the kind of model she was, and I think that's why everybody liked her, but she was never into it. When she was done with her work, she would wash her face, brush her hair the way she wanted, and she [didn't] give a fuck about what she'd just done. If someone told her, 'You were amazing today,' she would shrug her shoulders and smile.

"She was a little shy. Offbeat. I mean not your average girl. Offbeat! That's the only way I can describe it. She'd do and say things that were unusual.... She had a little bit of a twisted sense

of humor, you know, but she was fun to be with. Particularly if she liked you! And I was one of her favorites! Me and Garren were her favorites—[I know] because she said so. She also liked Way Bandy. When I came into the industry, he was more famous than any other makeup artist. He liked her! You know who else, even though he died really early? Perry Ellis. He was a very big American classic designer, and he loved her, too."

"I wouldn't say she had any difficulties [interacting with others], no more than anyone else I knew. You have to remember, we were sometimes working six or seven days a week, and it was intense at times," Mills says. He also recalls Bitten Knudsen, who passed away in 2008, as another model whose personality sometimes surprised others. "She was fabulous!" Mills continues. "She was a bit of a rebel, but she was another offbeat one."

Mills recalls one of the occasions on which he'd seen Bandy reveling in his element. "*Vogue* magazine used to do a very famous, glamorous breakfast fashion show, every year, at the Pierre Hotel on Fifth Avenue," Mills says. "They would hire the top ten models, and there would be two makeup artists and two hairdressers. So there was Way Bandy, myself, Garren and the other was Suga. That was the breakfast fashion show for all the editors. Way Bandy was the most famous—and had been since the sixties—and he was very friendly with Gia."

When Mills worked his magic on Gia, he did his best to create a relaxed, pleasant atmosphere. He had noticed that Gia didn't appear to be satisfied by the work she was doing. "I was always trying to make a photo sitting a lot of fun. If I made it more fun, she would have more fun. That's how I interpreted it. I'm not sure what [was in her] mind, but because I had the impression she didn't like the job, I was making it fun for her."

Much has been said and written about who most deserves to be known as the fashion industry's first "supermodel," a title that has been bestowed across the decades on such icons as Twiggy, Veruschka, Jean Shrimpton, and Lauren Hutton, to name only a few, and which some would apply to Gia. Reflecting on the many

models he encountered in his long career, Mills "number one" is clear in his mind: "I think number one was Kim Alexis," he says. (Alexis graced the cover of Mills' 1987 book, *New Classic Beauty: A Step-by-Step Guide to Naturally Glamorous Make-Up*.)

Gia, however, was one of Mills' "superstars," and the reason, he says, is that "the camera loved her! [Her] best quality was that she would be in front of the camera and the camera loved her. She did practically nothing—[she'd] look this way, look that way—and when the pictures came out, they were sexy, elegant, classic, very classy. They were everlasting. And she didn't have to work at it. It was natural! When Garren would do her hair, I would do her makeup, and after the job was done, we'd say, 'Go out and have dinner.' You know, anywhere. She loved to be seen, and everybody loved her to see her because she would walk in like a movie star! And she did that purposely because she thought it was funny! She didn't take any of it seriously. She would just have fun with the attitude."

Regarding Gia's preference for romantic relationships with other women, Mills demurs. "She was awfully young when she started," he says. "When I met Gia, she was probably eighteen. When you're that young, do you really know what you are?" What Mills is certain about is that Gia had no interest in chasing glory. "She was an amazing human being," he states clearly. "Just that. Not into the money and the fame. Absolutely not." From their work together in Milan and Rome, Mills has kept several poster-sized blow-ups of Gia's covers. When he looks at them, he says, "that's when I think of her a lot."

Mills, whose work includes makeup for the celebrated 1978 thriller, *Eyes of Laura Mars*, cherishes two other memories of Gia. On one occasion, he recalls, "we had to do a shot with wet hair. All of a sudden, after she got her hair wet, she turned me around and pushed me into the shower, just as a joke. I was all wet, but I never stopped doing makeup!"

The second anecdote took place in Rome. "[When we] stayed in Rome, Valentino wanted us to be in the most beautiful hotel—

the Grand Hotel," Mills says. "Gia was with us, and she enjoyed it. I remember Gia loving Rome! To stay there, even to walk into one of the restaurants or lounges—oh! And to stay there ten or twelve times during the collection—beautiful! [So] we were in Rome working with Patrick [Demarchelier] and Gia [showed up] on time. Everybody was surprised when she walked in the door at the *last minute*. I thought that was funny because everyone [expected her to be] late, but at the very last minute of the call, she walked through the door."

14

THAT'S NOT THE WAY
JAMES BOND DID IT!

In 1980, model Bob Menna flew to Barbados to do a shoot for the men's magazine, *GQ*. "I'm not sure if the Barbados shoot for *GQ* was the first time I worked with Arthur Elgort," Menna says, "but it was the first time I met Gia. In fact, I hadn't heard of her before then. I really didn't keep up with the industry and rarely picked up a magazine. I got to the location a couple of days before Arthur arrived and shooting [was supposed to start]. I was sitting in the house on that first day [with a group of other] models ... who were finishing up that day. This girl poked her head in the door, viewed all the models, and then looked over at me. I must have raised an eyebrow or something. Maybe my mouth was wide open, but she looked at me with this quizzical look. When I caught my breath, I said, 'Hi, why don't you come in?' It's difficult to describe the beauty I saw in her. There was something in her that was sort of like Lauren Bacall in *To Have and Have Not*. The thick mane of tousled hair, cigarette in her hand—she really didn't look like the typical model of the day. No makeup, her clothes looked like they were just thrown on or that [she'd been wearing] them all her life. That's how com-

fortable and confident she looked. To say I was attracted would be an immense understatement.

"She came in and sat down right next to me. I can still recall her scent today—not perfume but a musky sensual smell. She was acting kind of tough, bold, rebellious. All this took place in just a few moments. I forget my exact words, but they were something to the effect of, 'Just because you've taken my breath away, that doesn't mean you have to try and intimidate me, because I don't intimidate easily.' Now her mouth was open. She said, 'What?' and I said, 'Look, why don't we get out of here and go down to the beach?'

"We walked down to the beach about a mile away, I lit up a joint as soon as we left the house, and we smoked and walked and got to know each other. Turns out we were both street kids from the city, and the fact that I had called her on her attitude gained me respect. She let me know that.

"She already had *my* respect for not being a typical model, [for her] obvious street smarts, and [for] being completely without pretension. So, just when I was thinking 'What a lucky guy I am to be here in this beautiful place with this beautiful woman,' we broke through the woods [to the path that lead] to the beach. As soon as she saw the water, she started to disrobe as she walked, and this time my mouth hit the ground. I watched her continue on to the water thinking, 'God must have heard me. I'm truly in paradise.'

"As she got to the water's edge, I saw that there was darkness in the water. I shouted, 'Gia! Stop!' just as she started going in. It was full of sea urchins. She came hopping out on one foot, naked as the day she was born. I helped her back on the beach, but we were in the middle of nowhere, and no one was around. I had no idea where town was and there was no sign of civilization. I took a look at her foot, and the spines had fortunately not gone in deep. I found a bottle, broke it, sterilized it with my lighter, and begin to operate to remove the spines. She was lying back on her elbows all this time, not saying much—no cries of

pain, no panic. I couldn't believe how trusting and calm she was.

"[Once] the spines were out, I needed to clean the wounds and had nothing to do it with. As a surfer, I knew urine was the appropriate antiseptic in these situations, but I was thinking, 'How am I going to tell this girl who I met less than an hour ago that I have to pee on her foot?' Before I just pulled it out and did the deed, I looked around for another bottle. I found one, and I explained to her what I was going to do. Now she was the one raising her eyebrows.... As I was pouring the contents of the bottle over her foot, [all the while] looking up at her resting on her elbows and admiring her nakedness, she shook her head in a kind of disapproving way and she said, 'That's not the way James Bond did it!' [Gia had recalled the famous scene in the 1965 James Bond film, *Thunderball*, when Sean Connery bites a sea urchin spine from Claudine Auger's foot.]

"As I finished pouring out the last drops, I said, 'Don't worry, honey. We can do James later!' Really, that's how I met Gia. Perhaps it's a little like the story of Androcles and the Lion. For me, she was tamed. From that moment on, it was like we had known each other eternally. [When we got to the set of the shoot], most of the time, we were hardly aware of Arthur being there. One the things I have always admired about Arthur's work is his ability to capture moments in time that are as much documentary as they are fashion photos."

Menna remembers Gia not solely as "a unique beauty" but as a "real straight shooter. [She was] no nonsense," he says. "She put it all out on the table. She had a lust for life and a magnetic personality.... Her ability to be herself in front of the camera was what I thought made her so special.... I think she enjoyed the travel, the money, but I think she shunned the notoriety and being fussed over. I never saw her in a diva moment like many of the other girls. I always got the feeling that modeling wasn't the be-all, end-all for her. That if she fell from grace, she would be happy returning to a 'regular' life. Another thing we had in common was that neither of us had aspirations to be a model.

We both sort of fell into it. With me, my first job landed a *GQ* cover, so there was no struggling after that."

Recalling Gia's relationships with friends and colleagues, Menna never observed Gia in difficulty in her interactions with others. "If she didn't take to you, she wouldn't fake it, so in that sense some people might have seen it as difficulty interacting," Menna says. "I saw it as a sign of *strength*. [My] suspicion is that what others might have seen as difficulties were more just her preferences. Her lust for life, her non-conformity, her rebellious attitude—that's what make her so memorable, and wonderfully so. Most of us conform to society's norms or spend our time trying to change the society we live in, [but that] wasn't a necessity for her. I believe people *vicariously* want to have a bit of what she had.... She had the ability to leave a small part of herself with everyone who came in contact with her. I know she did for me.

"We were all using drugs in those days—it came with the territory. I never thought of her as having any mental or emotional problems, but then again when we were together, it was just the two of us. We never argued. I never saw any mood swings. She was constant and consistent with me.... Ours was a physical, sensual relationship, yet we both knew and respected each other. We were the essence of a "no strings attached" relationship, yet we both understood that didn't mean we didn't care for each other. One cute thing I remember is that often in intimate moments, or when we were around others and she felt like showing some affection without it being known, she would call me James. We loved each other in our own way. We never said 'I love you' to each other, but we never needed to.

"One summer, back in the eighties, I volunteered as a manager at Bailey House, a residence in the Village for homeless people suffering from AIDS, so that the managers could take vacations. During that time, I saw first-hand the fear, loss of dignity, and personal suffering of those who contracted the disease and the effects on their family and friends as well. I've blocked all of that out with regard to Gia so that my internal memories of her can

remain untarnished. In remembering this, I realize that, while I might have covered it up, it wasn't really as blocked out as I thought. She was a wonderful, beautiful girl, and I still to this day have trouble coming to terms with the fact that her light is no longer with us."

15

THROUGH THE LENS

The photographer Eric Boman, one of *Vogue*'s go-to artists as well as the author of a book on interior designer and fashion icon, Iris Apfel (*Rare Bird of Fashion*), says he has "stayed afloat" in the fashion industry because of the many interests he has maintained outside of fashion. He recalls Gia as "a very special girl, and I know that from what her face told me. She had a mysterious, smoldering sensuality without a trace of vulgarity. It was new and touching, something that isn't often encountered. Perhaps it was her troubles that gave her that elusive quality, and perhaps it was wrong that they should be 'used' for what were essentially commercial purposes. I know she had many friends—sadly, many of them are gone. They blossomed, almost too brightly to be able to sustain it, and it wore them out.... I was surely also not the most indulgent person to work with. That said, I'm still in touch with the ones I got closest to that are still around. Still, I was certainly too strict for Gia to be comfortable, and I remember one time at the studio she suddenly said she had to go down to the street to feed the parking meter. She never came back. Like a feral cat, she had escaped. We all knew it because my street didn't have parking meters and she didn't have a car."

In 1981, Isabel Russinova, the well-known, Bulgarian-born Italian actress, happened to cross paths with Gia as the two waited for their separate photo sessions to begin at the offices of *Harper's Bazaar* in New York. Though they talked for only a few hours, Russinova was struck by Gia's "natural beauty and her soft, delicate figure. She [seemed like] a frightened fawn," Russinova recalls. "Gia was an old-fashioned young woman, like an outlaw from the 1800s. She was *restless*, and that restlessness was attractive to men because it smelled like sex." To Russinova, Gia appeared slightly "impatient," but the overall impression she made on Russinova was positive. "She was a normal young woman who emanated enormous sex appeal," Russinova says. "Unlike other female supermodels, Gia didn't seem inaccessible—quite to the contrary." For her, Gia was the embodiment of the girl next door.

The Italian photographer, Renato Grignaschi, who worked with Gia through the darkest years of her career, agrees. "She was a beauty," he says. "She didn't have the classic model's attitude, but she had an enchanting, magnetic way of looking at the camera." Grignaschi recalls that Gia "didn't talk much." When she did communicate, however, she did so through her "deep, incandescent gaze. She was aggressive, wild, and charismatic—not dark in any way—and she was hungry for affection," Grignaschi adds. "She was comfortable with me because I respected her. I admired her a great deal, and the feeling was mutual." Grignaschi's experience with Gia echoes Maury Hopson's comments about how Gia's behavior on the set was connected to the degree she felt respected by the people working with her. In fact, Gia never once failed to show up for a photo shoot with Grignaschi.

Fashion photographer Stan Malinowski, who broke into the field with photographs for *Playboy* and *Penthouse*, worked with Gia on only a few occasions in New York and California, but he found Gia to be "happy, playful, and spontaneous, both as a model and as a person. As a model, she was uncommonly inventive. In fact, I can think of only one other model whom I photo-

graphed during my thirty-plus years as a photographer who was as likely to create unexpected and original poses—Judy Newton. Gia, in a sense, quite like a talented actor, took on the persona of the part she played as a model. Gia seemed happy in general, and she was a good model. It might be inferred that she was happy to be a model. The days I worked with Gia, she was outgoing, personable, and lots of fun."

The maestro of hairstyling, Sergio Valente—owner of the Sergio Valente Beauty Atelier on the super-fashionable Piazza di Spagna in Rome—was present at one of Malinowski's memorable photo shoots with Gia, though he actually worked with her a total of twice, Valente recalls—"for *Vogue* USA and a cover for the *Vogue Beauty & Health Guide*." A man of old-fashioned charm and disarming humility (despite numerous awards and a glorious career spanning more than five decades), Valente says simply of Gia: "I recall that she was very quiet. She was truly beautiful."

Before Richard Warren became a fashion photographer in 1986, he worked as a photographers' assistant to many of the big names in fashion in the early 1980s. He recalls working with Gia on several occasions. "I found her to be very professional, pleasant, engaging, and, of course, very beautiful," Warren says. "She had a 'childlike' quality that I remember, and it worked for her. It was an endearing trait. As a young heterosexual male, of course I took notice that she wasn't shy about walking around topless while changing garments. Although assistants were not high on the totem pole among photographers, Vogue editors, and creative directors, the shoots [themselves] were small and fairly intimate. The assistants were also the only ones on set who were close in age to the models. It wasn't uncommon to hear about a top model going out with a famous photographer's assistant. Gia's accomplishments were more than being a supermodel—even before that label was [widely] used. When Gia started, most of the top models were blondes. In fashion, there are trends in clothes [just like] trends in the models who wear them. Blondes, many of them from Sweden, dominated the agency ros-

ter boards. Any model in 1980 who wasn't blonde had her work cut out for her. That included Janice Dickinson, Esmé [Marshall], Gia, and a handful of others. Later, in the eighties, when Cindy Crawford started and was labeled the 'Baby Gia,' it was much easier for non-blondes to be accepted. I think we can credit Gia for breaking that trend."

North Dakota-born photographer Lane Pederson recalls Gia as "an exquisite lady. I worked a lot with her, and she was very nice. She was a very warm and wonderful person. She had a fun personality. One time I was doing a shoot for a lingerie commercial. There was a guy and Gia in the picture, and while I was shooting them, they just started to make love. It was an amazing thing to watch, because of the chemistry [between] Gia and the male model. I think [Gia] was very [happy to be a model]. She enjoyed it very much. On the surface she was very sensual.... Any depression she might have had didn't come through in the photographs or while she was working."

When he met Gia in 1979, David Radin was the studio manager for the celebrated photographer, Francesco Scavullo. "The first time I saw Gia at Scavullo's studio, she took my breath away," Radin remembers. After the shoot, he "told my friends outside of the business that I had met the most beautiful girl in the world and wait until you see her. I had the pleasure of working on many amazing photo shoots with Gia."

Radin recalls an amusing anecdote that brings to mind Suzanne Rodier's words about Gia being "outrageous at work." On this particular occasion, Gia and Janice Dickinson were being shot in a photographer's "trendy SoHo loft," and Radin was assisting. "Gia arrived a bit late and glazed over," Radin recalls. The session got off to a rocky start when Gia insisted on doing her own makeup, but after "some negotiations," Gia relaxed and the work day officially began. Radin "set up the lighting, and we all waited for the 'glam team' to finish [hair and makeup]. Needless to say, it took longer than expected. [At some point], Gia locked herself in the bathroom, wiped off all the

makeup, and started to do it over herself. They were pleading with her to come out to start the shoot. When Gia [did come] out, she was argumentative." After discussions with the client, Gia was asked to leave. She was upset, but she picked up her belongings and left the studio.

Radin continues, "I was a little concerned about some sort of retribution, so I stuck my head out the window and looked down to the sidewalk to make sure she [had really gone]. I saw Gia ... walk a short distance, pick something up, and return to the building. I ran downstairs and discovered that Gia had tied the door handles together with some rope she found in the street. I couldn't get the doors open no matter how much I pushed. I started yelling through the door crack to anyone who happened to pass by—but remember, back then there was next to nothing going on in SoHo on the weekend, and it was a ghost town. After twenty minutes or so I got the attention of a passerby who unraveled the knots. I returned to the shoot and logged the moment to memory. I didn't know Gia outside of the photo shoots, but she made the most lasting impressions."

Gia created another "lasting impression" on a location-shoot for Scavullo at his luxurious Southampton estate. Because the day was cloudy, Radin recalls, "we weren't shooting. Scavullo only shot daylight in a clear sunrise or at sunset. He loved the low sun. The crew was lounging around the pool, drinking white wine. Surprisingly, Gia appeared in a T shirt and jeans and said hi. I say surprisingly because Gia was intensely private. There was some friendly chit-chat, and Sandy Linter [went over to hug] Gia.... A split second later, the unthinkable happened. The second photo assistant, a brand new guy named Ernest, sprang out of his chaise and pushed Gia and Sandy into the pool. It happened right in front of me. I immediately recognized the disaster unfolding. Gia surfaced, pulled herself out of the pool, cigarette still in her lips. That's the image that has stuck in my mind all these thirty-something years. Gia, stunningly irate, threw the wet cigarette aside and shouted at Ernest, 'Who the

fuck do you think you are? You don't even know me!' The group sat in shock, in absolute silence. Arguably the most beautiful woman in the world was seething mad. Gia left in a rush, and the crew remained by the pool. Ten minutes later, Francesco came storming out to the pool, dressed in a bathrobe and holding a coffee mug. He shouted angrily, 'Who pushed Gia into the pool?' He pointed to me. 'Was it you?' I said it wasn't. Ernest stood and admitted pushing Gia and Sandy. Francesco shouted, 'You're fired,' and smashed his coffee mug on the poolside patio. Pieces of cup went flying into the pool. Francesco told me to put Ernest on the next train to New York."

Nicholas Prins began working as Chris von Wangenheim's photo assistant at a [1979] shoot that became notorious. "It was my first day at work with Chris," Prins says. "[The scene] is in that movie with Angelina Jolie [a 1998 TV movie of Gia's life]. We were shooting for *Vogue*. [The photos from this session, in which Von Wangenheim shot Gia against a mirrored Plexiglas background as well as both clothed and nude behind a chain-link fence, made her famous.] After the shoot, Chris said, 'Do you want to stay around? I'm going to take some pictures for my book.' And I said sure. I remember Gia and Sandy Linter coming back out pretty much naked, and [I thought to myself], 'Yeah, this is the job for me!' But earlier in the day, when I was modifying lights and stuff like that, Gia was always very pleasant to me. That was a day I don't think I'll ever forget."

For photographer Michael Doster, who worked with New York's most prestigious fashion houses and whose book, *Michael Doster: 80s/90s*, includes photographs of Gia, "Gia was "one of the most beautiful girls ever! She was the nicest, sweetest girl to work with.... I worked with her at the very end and we could only take shots of her with long sleeves. And you know why—because we couldn't shoot her arms anymore. But she was very nice, and of course it was so sad that [someone] like her who had every, every possibility from the very beginning ... destroyed her life. And to go so soon....

"You do know she liked girls? She flirted with guys, but she was very masculine—masculine with this incredible, feminine beauty. She had great style in the way she dressed. I remember she walked in [wearing] a white man's shirt and tight jeans in a way nobody would wear them. And she was just stunning! She was just a kind, kind girl.... [Even though people like to] believe that beautiful girls are bitches. In a way, she was like a little puppy.

"The second time I shot her, it was so sad because it was one of the last shoots that Elite and John Casablancas sent her on. Casablancas asked me, 'Please, please, shoot her. She needs the money.' We knew already that [no one was] sure if she was coming or not, but I still [agreed]. At the time, you could [still] show her with long sleeves. [But] I could only do two or three shots a day because she was feeling very tired. The good thing was that she was just so wonderful with colleagues and the other [models]. There was this combination of beauty and sadness, something unbelievable, but then again [that was when things were starting to go downhill for Gia], so I'm not sure if it was the combination of labor and being with a girl or whether it was time for her to go. [Gia] was in love with her, but I'm not sure she was the best thing for [Gia's] life.

"I can only say positive things and nothing else. She had that twinkle in her eyes, a great sense of humor. She liked jokes and not taking herself too seriously the way most girls [like her] do because they think they are the best and the biggest. Her body and her looks were totally like a woman's but the thinking and the mind was more like a man's. That combination was just fabulous. She was absolutely like a tomboy. I remember one time I had to take a picture of her with another girl [referring to the *Woman into Man* photo shoot]. The [other female model] was supposed to be a guy, and they were lighting up a cigarette mouth-to-mouth, and Gia could play that number. She could play it both ways, and she was so great about it. But you could see the way she looked at other girls that she liked the girls. You just could see that. My memories are only the best. I'm still fascinated by her beauty and by her character."

16

WHAT'S THE BAD NEWS?

Albert Watson, the award-winning, Scottish-born fashion photographer and one of the most mythical figures in contemporary photography, has these memories of Gia. "I think Gia felt quite comfortable with me because I wasn't involved at any time, in any way, to any degree at all with drugs; and therefore, she knew I was, in her words, very straight. She knew I wasn't in that world at all," he says. "I think sometimes she had respect for that. She did her best to come to the studio and secondly to come to the studio on time. Sometimes I would tell her, 'Try to get here on time, and I'll get you out of here early.' Or I often said to her, if I was booking her for four hours for a cover—[like the cover] I did with her for French *Vogue*—I'd say, 'Look, I'll make it eleven o'clock, so it's not early for you. It's not like a seven a.m. booking. I can probably [get you out of makeup] in an hour and a half, and I can probably shoot a cover on you in thirty, forty-five minutes.' So, with a bit of luck, a four-hour booking is really only two and a half hours, and [she could] leave early. Or [I'd offer] to shoot it at five o'clock in the evening, so [she could] leave at 7:30, 8:00.

"I think she appreciated that philosophy, and I found her

interesting. There are tons and tons of beautiful girls around; there's an endless supply. There are hundreds of them, if not thousands. But then, if you add the word 'charismatic' to it, you cut that back by as much as 90%. So for every hundred, you have ... maybe only ten that have that charisma. Then, if you add 'unique charisma,' it goes all the way down to one out of a hundred or even one out of a thousand. Gia had that quality. That's what made Gia unique. Gia never learned to be a really great model.... She relied heavily, of course, on the fact that she was amazingly beautiful and charismatic, but she was never a great fashion model. That's one thing that people don't realize. They sometimes see a girl that's tall, slim, beautiful, amazing eyes, and the body is perfect [and then] when you put that person on the set, [she] just stands there with [her] clothes on. You need a lot more than that. You need a certain amount of body language, a little bit of dance philosophy in the head, a little bit of move-ment, and also an awareness of pose. But basically, when I was photographing Gia, it was always ... a portrait philosophy and a beauty philosophy. [In other words], you weren't asking her to move around too much [or] pose in the dresses and so on. That's why she was always good for beauty art or to do a cover. I liked her as an individual.

"Even when you have a hairdresser, makeup artist, stylist, and other people on the scene, there's still a certain moment when, basically, I look straight ahead of me. I have my camera, and there's Gia in front of me, and I'm the only person in front of her, and she's looking at the camera and at me. So there is a certain moment there [between us]. And she knew I liked her. I did have one of the best covers I ever got with Gia, a *Vogue* cover. It was a super simple shot. She was wearing a blue sweater. It couldn't have been any simpler, but she was real. There was something in that moment that was quite special.

"She could be infuriating at times," Watson goes on, "but I think what she liked with me was that I was more of a busi-ness person, and she knew I was straight. She wouldn't come in

the studio to get drugs from me or [imagine] that I would share [drugs] with her. I'm sure there were drugs sometimes [available from other people] when she came to the studio. I think she respected what I was doing. Gia was kind of tough. Sometimes she was really tough, and at other times she was quite sexy. She had a good voice. And that's why people found her interesting."

There were, of course, those who said Gia should or would have become an actress, and not solely because of her obvious physical beauty or distinctive voice. Watson pulls no punches in responding to such an idea. "It's everyone's fantasy that somebody like Gia [will become an actress]," he says. "There are tens of thousands of models who tell you, 'I'm going to act!' Very few can. Sometimes, you look at an actress and you trace back her history, and she did a couple of modeling jobs, and you think, oh, she used to be a model. I mean, Martha Stewart used to be a model. So they might have done a bit of modeling to make some money, but their mission was to be an actress. And, very, very, very few models, very few models can act, very few. I know this because I've done so many TV commercials [in which] I needed somebody to deliver lines. Very often I would pull in models for the casting that I thought could do it because of their personality, and the minute they got the line, it would be a disaster. They couldn't do it. I think it's a little bit odd.

"I did work with one model who was actually very, very good—a good model, clever, beautiful—and she had a strange ability to deliver a simple line. I talked with her about it, and she said to me, 'To be honest, it's the easiest thing in the world.' But of course not everybody can do it.

"I'll tell you one thing, if you had gotten ahold of Gia when she was five years old and put her in a different environment and monitored her the whole time, and made sure there were no drugs, and [sent her] to acting classes early on, then—maybe. But that was never going to happen. She headed down [a different] road herself. In life you make a decision. 'Am I going to go on that road and end up in Miami or end up in Boston?'" She ended

up in a road going that way. I can say I don't think she had the [ability] to deal with the situation."

Admittedly, the list of female models who become actresses and can then boast of long, successful careers is not extensive. Even within the fashion industry itself, staying on top for more than a decade is a struggle. Those who make it are a cut above the rest—professional, determined, and—there's no use pretending otherwise—blessed by genetics.

Watson agrees. "It depends on how good you are," he affirms. "A really, really good model can have longevity. I mean, Cindy Crawford's still modeling. I remember working with her in 1983, I think it was…. Very few [can do it], but that's life. The same [is true for] everybody—photographers, too. If you look at magazines, there are tons of photographers [who were] around in the 1980s, and you don't remember who the hell they are now, where they are now. It depends on how good you are and how much passion you have. I was lucky because I was doing many different things. I was doing portraiture and doing movie posters and doing HBO posters and all of these things. So I had two or three photographic careers."

The cover Watson shot of Gia for French *Vogue* remains one of his fondest memories of her. "When I did that French *Vogue* cover, that was the one time I remember just having a little laugh with her," Watson says. "I told her, 'I have to say, you look really beautiful.'

"And she said, 'Thank you!'

"And then I said, 'And the good news is, I'm gonna get you out of here in about twenty-five minutes!'

"'What's the bad news?' she asked.

"I said, 'There is no bad news! You are out of here in twenty-five minutes.' And on the cover you can actually see that she's got a little touch of a smile. That was a nice moment!"

17

JUST GIA

Wendy Whitelaw, the iconic and eclectic glamour illustrator and makeup artist, remembers Gia as a "very charming, sarcastic, beautiful, needy, boyish girl. She and I were both kind "rebels" or offbeat, artist types.... So we had that attitude of fun about work [whereas] other fashion people were really thrilled to be well-known and famous. Not to say we weren't very good at our work—just a bit maybe 'punk' or silly-serious. We had that in common. She didn't feel puffed up about being a famous model. In fact, she was often irreverent.... She walked around and behaved like a guy, but then when she was in front of the camera, she was amazing. It's like she switched personalities. She was a regular girl from Philadelphia—not into fashion—and then, when she was in front of the camera, she [became] the most-beautiful-woman-in-the-world type. It was natural for her. The camera loved her.... She was a dichotomy. When she walked off the set, [still wearing] a beautiful gown, she'd [go back to] walking like a tomboy.

"She was so funny. [There she'd be], wearing a ten-thousand-dollar gown, and she'd sit down on the ground with her legs [spread]. All the other girls were there to be models, but

Gia didn't really care about the modeling. I think she wanted to be a writer. She wanted to do other things, but she got snapped up so quickly because she could be just amazing in front of the camera. It was unusual because she wasn't into it. But it worked. She didn't do a lot of posing or faces. At the time, they wanted models to do natural pictures, and she was a natural.... Sometimes it worked in her favor that she was anti-fashion.

"I liked that she was so rebellious and so innocent about modeling. Every other girl in America wanted to be a model.... I felt really bad for her because she wasn't made for modeling. She wasn't the type. [Modeling] just happened to her, as so much stuff does in New York—all of a sudden you have a career, and you weren't even looking for one. She happened to be gorgeous, and she looked great in pictures. [The trend] at the time in the industry was for the girls to be 'sneering' in their gowns or [with their] dresses half falling off, so that kind of sarcasm worked in Gia's pictures. It was perfect timing for her. But it wasn't good for her because she wasn't impressed by it. No one really cared about her. She was a rebellious girl, and she was doing exactly what she wasn't supposed to do. She wanted a 'story.' She wanted to make an impact, not just be a model. She didn't want to be just a plain, ordinary, successful model. She hated that. She wanted *more*. She wanted to write. She was always trying to learn to play her guitar, and read a lot. What I'd see her read were either rock-and-roll things or William Burroughs-type [books]. She didn't have a lot of good friends. I think people hung around her for the wrong reasons, and that's why a lot of time she would come over to my house and hang out. She just wanted to hang out [like] a normal person. [It wasn't like she] came over [dressed] in a gown.

"Modeling was something that [had] never crossed Gia's mind [before she became one]. And although she [appreciated] the money, she needed people to love her. So she was very bright on the set when people thought she was beautiful and looked great, but she wanted people to like her [when] she was different, and [they] didn't always. She liked being accepted, but she felt stupid

at the same time for being a model because she thought that wasn't the core of the universe. She thought being a writer or poet or musician would be more important."

Whitelaw was also a habitué of the Mudd Club, the music club where Gia happily spent much of her precious free time. "I saw her there, but I didn't go with her," Whitelaw says. "I was one of the first Mudd Club people, so I was there every night, and sometimes she was there." But Whitelaw and Gia did spend a lot of time together in other venues, "hanging out at night, because she partied a lot, and going to the clubs. I liked her because she was very fun to hang out with, but it was more like hanging out with one of the guys. I never knew her to be in any relationship for any serious length of time. She badly wanted to be loved, but I think maybe she was hard to be with, cocky.... She pursued me and many others in a kind of manic way, which [left a lot of people speechless], and she seemed to like [being] shocking. It [brought her] attention, which she needed more than anything.

"About half the people knew about her problems and half thought she was just being strange and butch. (Almost) everyone was doing drugs in these days. It was the eighties; it was a normal thing. I think everyone wanted to act cool and not say anything. I never saw her ask for help. She was that kind of person—she thought everything was all right. She was very confident. To me, she was trying to keep this big secret from the fashion business, because they started to find out, and everyone was watching her carefully. That really upset her, so she was trying to hide that and to act more normal. And I don't think people were trying to help her." At the same time, Whitelaw acknowledges, Gia could be "kind of sneaky. She was mysterious in certain ways."

Chuck Zuretti was Albert Watson's photo assistant when Gia made her debut as a model, and he recalls working with her for the first time in Paris on a shoot for French *Vogue*. "She was a new face, a very interesting and attractive face," Zuretti says, recalling an amusing anecdote from that shoot. "At that early stage of her career, she knew what she liked and what she didn't like.

[On the] shoot for French *Vogue*, the hairdresser and makeup people spent about four hours working on her. Finally she came out with her hair and makeup finished, wearing a beautiful dress. She looked in the mirror at what they'd done, and she walked over the sink and washed her hair out. We'd been waiting for four hours and she just didn't like what she saw. So she just shoved her head under the water and washed everything out," he laughs. "We had to wait another three or four hours to get her back.

"I didn't spend a lot of time working with her, but she wasn't Albert's favorite. I think because she was so quiet and somewhat emotionally heavy. I'd say it that way. Albert preferred models who were more upbeat, a little happier, so he could make jokes and get things out of the models that way. He wasn't into the deep, solid, moody kind of photography. But Gia was beautiful. She had a really intense personality from that standpoint.

"In my opinion, she wasn't happy [modeling]. Period," Zuretti observes curtly. "She was happy she could make money, but she wasn't affected by it, that I could see—as if it was just a job for her. She could have been working in a restaurant as a waitress, and it wouldn't have made any difference. I suppose modeling allowed her to travel, and meet people that were more [on her wavelength]. When you work in a business and you travel so much, you meet a [wide range] of people—more than normal people [have a chance to do].

"From that standpoint, she was probably happy she was a model, but I also think she experienced a lot of unhappiness. I don't want to be a psychiatrist, but there must have been some trouble.... There she was shooting for French *Vogue*, and I think the last thing on her mind was, 'I'm shooting for French *Vogue* and I need to be good.' I don't think it entered her mind at all.

"She would put the dresses on, have her makeup and hair done, and then she would look at it. If she liked it, it was OK. She would walk out there and say, 'What do you want me to do?' or she'd sit and try something for you. [Whether or not she took directions well] really depended on her mood at that moment.

If her mood wasn't good or she was in a bad place, she wouldn't listen. She wasn't connected to the work she was doing. Other times, she would be better, and if you told her, 'Move your right leg,' then she would move her right leg.... If she was in a good mood, she would take directions. If she was in her own place, she wouldn't. She was just Gia. I think people realized that and didn't fight with her.

"She was different from most of the models we worked with. There were some models who were difficult, some who were easy, and some models who were fantastic. But she was a completely different kind of model.... I think she suffered emotionally, and that made her very cautious, very careful about whom she allowed to become her friend. She didn't trust a lot of people. Forgive me, but she had an 'I don't give a fuck' kind of attitude. 'I don't care what other people think—I'm just going to do things my way.' For a young model [to do] what she did for French *Vogue*—after we had waited for her for four hours, then washing [all her makeup off and undoing her hair]—that's pretty much like saying, 'I don't really care,' 'fire me,' 'don't use me, whatever.' And she didn't care."

Gia's "*je m'en fous*" regarding what others thought of her only went so far, however. Behind that rebellious exterior, Gia concealed a deep desire to be liked and accepted—characteristic of those who have lived through experiences of rejection. Laughs Zuretti, "In the world of fashion, I think that makes people a little more hungry, meaning they want you more. What you want badly you won't get, and what you don't want, you get. Exactly like that. The personality of a lot of people who work in fashion is that, in some ways, they feel rejected, and I think that then makes them more beautiful. It gives them something special. What I mean is that sometimes it's easier to love someone who is more complicated."

18

CAREFUL WHERE YOU PUT YOUR HANDS!

Discovered by chance, as were most of his colleagues, the model Alessandro Stepanoff shot into the spotlight quickly (the Italian maestro of fashion photography, Oliviero Toscani, noticed Stepanoff working at a greengrocer's in Milan). Among Stepanoff's first jobs when he arrived in New York was a famous Versace campaign. Photographed by Richard Avedon, the series involved some of the best-known faces in the industry. Avedon observed the chemistry among Gia, Stepanoff, and Jason Savas—a trio that seemed to exude a *caliente* Mediterranean sex appeal—and had no doubts about posing the three of them in several shots. Though Stepanoff couldn't say two words to Gia (he'd only been in the United States a short time and barely knew any English), he recalls communicating with Gia "using gestures."

Stepanoff only worked with Gia briefly, but he remembers two spicy anecdotes from their time together on the Versace photo shoot. In one shot, Gia has her left hand hooked into the waist of Stepanoff's trousers, her thumb dangerously close to an "X-rated" area. When the photo appeared in *Vogue* Italy, the

magazine considered the photo obscene and decided to censor it. In the end, the shot was heavily darkened for Italian publication to obscure the offending digit.

Stepanoff's other memory of the Versace photo shoot had to do with Avedon's request that Stepanoff pose in the nude with a fully-clothed Gia. "It was just for one photograph, and they were paying well, so I decided to do it," he says. In the photo, Gia, dressed all in Versace, stands regal as a Greek goddess above a naked Stepanoff, who reclines at her feet. With her right hand, Gia yanks a lock of Stepanoff's hair; her left heel and ankle are strategically placed to keep too much of Stepanoff from appearing in the photo.

Stepanoff also remembers that Gia gave him a ride one evening after they'd finished work on the ads. "She had a Fiat Spider 124," Stepanoff says. He has no doubt about the make of her car, he adds, "because I had one just like it."

Jason Savas recalls that his first memory of Gia was "Wow, this girl is gorgeous, but I never got to know her as a person. Gia was very quiet, reserved, and she kept to herself during shoots. I don't know if she was doing drugs at that time [1979]. I never remember her mingling with other models, either on the set, or in their dressing rooms, or during lunch breaks. Gia was obviously an excellent model because photographers and editors raved about her, and all one needs to do is look at how she came across in pictures. The camera just *loved* her! The first time I ever saw and worked with Gia was in December 1979, for Versace. The last time I was supposed to work with Gia was either 1981 or 1982. She didn't show up for a television commercial, [which was] for Revlon Moon Drops Lipstick. Avedon had booked her without an audition—though 99% of the time, one had to audition for TV commercials.

"We were all shocked, especially Avedon, because that was the second time she had stood him up. I'd also been on the earlier shoot with Avedon. Gia went out ... and never returned to the studio.... Back then I never thought the reason was to buy drugs—but it probably was. Anyhow, another model [Rosie Vela]

was immediately booked and we did the commercial, but Avedon was angry at Gia and said he'd never work with her again, but eventually he gave her another chance.

"[The Avedon shoot for Versace] was exciting, especially because I was new in the business and Gia was in a bathing suit. I had to wrap myself around one of her legs. I couldn't believe my luck, and I was getting paid! In my opinion, Gia didn't seem to care about the business, especially all the easy money they threw her way. Looking back, I now see she was very troubled. But one thing is clear to me—money wasn't her God! Sometimes Gia wouldn't talk to anyone during the entire shoot, and she just went through the motions on the set. I believe she was very shy and introverted. But what is hardly ever mentioned is that Gia was gay. As I think about it now, I realize that was very hard on her and contributed [to her difficulties], along with the fact that she'd entered the business at such a young age."

Hairdresser Edward Tricomi was also present the first time Gia disappeared from one of Avedon's shoots. "She said, 'I'll be right back, I'm gonna get some cigarettes,' Tricomi recalls, "and she left. She just left. The editor said, 'My God, I'll never work with her again!' and blah blah blah. Avedon turned and said, 'No, no, no. Book her again tomorrow. Book her for tomorrow. We'll get her tomorrow.' So he booked her the next day, and he bought her cartons of cigarettes and he stacked them on the makeup counter…. When Gia came in, he said, 'This is for you in case you need cigarettes. I bought you a couple of packs.' She started to laugh and said, 'OK, I'll take the cigarettes and I'll work.' You know, she was a good model, but I think she didn't care about modeling."

Savas's and Tricomi's statements make one thing perfectly clear: It wasn't Richard Avedon who put Gia on the fashion industry's blacklist. In fact, Avedon had forgiven her and sought to work with her again not once, but twice. Nor did these episodes, by themselves, have serious ramifications for Gia's career. Rather, Gia had begun estranging herself from the industry on her own. She was aware that her drug problem had begun to be known and that

people were starting to talk behind her back—spreading rumors, as so often happens, even about things that had never taken place.

Savas recalls another incident in which he worked with Gia and several other models. "Gia wouldn't leave the bathroom for long periods," he says. "It became obvious what she was doing. But no, I never had the impression she might be suffering from anything simply because I was a very naïve twenty-four-year-old and was completely unaware of mental disorders and depression. I considered myself so lucky to be in the business, and I wasn't going to screw it up. I thought everyone thought the same way. I was relatively new, and I didn't even know who Richard Avedon was at the time, nor had I ever heard of Versace."

Returning to the Avedon shoot for the Versace campaign in 1979, Savas says, "I do remember Mr. Avedon's enthusiasm and energy level. At lunch he told us that once he started shooting, he could go all day without eating because he was so excited and got lost in his work. The first Versace ads were shot at Richard Avedon's studio on East 75th Street; the set was stark white and surreal, and you lost all depth perception. You couldn't see the curve in the wall where it met the floor. The entire shoot was very exciting for me—first class all the way, beautiful models, the best hair and makeup, [the best] clothing stylist ... [and then] watching Avedon pose each shot with his large 8x10 format camera, [which meant the models] had to hold their poses longer than usual. Gia was one of several stars that day, along with Renee Russo, but Gia happened to be my favorite."

19

STAR QUALITY

Among people who worked in the fashion industry, Gia was considered one of the most alluring models—as well as one of the most beautiful women—of all time, but was Gia truly aware of the beauty she'd been blessed with? Suzanne Rodier has no doubt. "Yeah, she knew what she had," Rodier says. "She knew what God gave her [and she] always appreciated that. She knew she had a gorgeous body." Still, in Rodier's view, Gia's beauty wasn't the source of her problems, nor was it a "curse." Rather, she says, "You knew [something] was just lacking deep down inside."

Though Gia was sometimes considered physically similar to Hollywood divas of the Golden Era, her beauty set her apart from her contemporaries. She had no peers, and there has been no one like her since. At the same time, as Maury Hopson makes clear, Gia's similarities to Lauren Hutton, a woman who might be called "a model's model" (for the extraordinary length of her professional career if nothing else), mean that analogies between the two may not be entirely off-base.

Hutton and Gia "had a certain mutual spirit," Hopson muses. " I started working with Lauren at the very beginning of her

career, and she was considered a breath of fresh air in the photo studios. The biggest difference between the two was that Lauren loved modeling and was happy that people responded to her unusual facial features, which were different from all the successful high-fashion models of the time. Makeup artists weren't on every shoot then, in fact—only on very special sessions. Models did their own hair and makeup and learned from each other by trading tips and techniques. Lauren absorbed all of that information like an eager kid anxious to 'make the team.' She studied lighting and how it could change everything.

"For Gia, it was like a moon landing—she never thought [any of it] was in her grasp. She was more at the mercy of the machinations of the business, and she was thrust into a success beyond anything she was prepared to handle. I would say that Gia and Lauren identified with 'outsiders' of the business more than they did with designers, photographers, editors, etc. But Lauren saw the opportunities available and, sadly, Gia was never aware of her potential.... Lauren was much more famous to people outside the fashion and beauty industry. Gia has become more famous since her death and [after] the movie of her life [the 1998 TV movie, *Gia*, starring Angelina Jolie]. Remember too, that Lauren was the first model to sign a million-dollar contract. In the [early 1970s], no one had a deal like that. Lauren was aware of her worth to a company like Revlon. I don't know if Gia and Lauren ever met, but I'm sure Lauren would have felt compelled to advise her about her career if they'd become friends. She would have recognized Gia's vulnerability under that rebelliousness, which most everyone else accepted as strength."

Lisa Ryall, one of Gia's most beautiful former colleagues and today a highly-regarded real estate agent in Los Angeles, also remembers Gia as the personification of the outsider. "She actually didn't have any interest in modeling, to be honest with you," Ryall reflects. "She wasn't one of those girls who showed off [or who] decided she was a beauty queen and was going to become a model. [And that is] a rare and unusual statement about the

times. I think one of the most important elements of Gia as a human being was that you never took the street out of Gia, you know? You never took where she came from away from her. A lot of people would come into the business and disguise themselves with some kind of fake story. I mean, even the best did that. Blustering about the great history of their family lineage.... So here was basically a [kid from the streets] ... a tough girl, and her toughness stood out as beautiful in that moment because the eighties were a breakaway time in every way. And she was great. People loved to photograph her—she was a wild animal and very free. Her life force wasn't based on an idea about herself. It was [something you could actually experience being] around her. Which is why you're writing about her right now.

"I worked with her when she first hit New York, probably on her first job, because I think she came with us to Italy.... I believe she came on the *Harper's Bazaar* shoot that Patrick Demarchelier did when I went [to Italy] for the collection. She was very shy, very complicated and mysterious in a way because she didn't really know how to [behave]; she didn't know social etiquette whatsoever. She was thrown into this world of beauty and ... of model chasers. She wasn't impressed with all that, but she was kind of enamored because of the attention.

"Gia wasn't a troublemaker or an instigator of useless conflict. That wasn't her thing. Gia was so isolated, in her own way, and there was a sadness about her. It was very touching. I remember reaching out to her. I had already been 'around' a little bit, and I had [my own] apartment on the East Side. We [models] had a nice life together ... and it was a nice world. And she didn't understand that yet. I remember [inviting her to my apartment for the first time]. It wasn't glamorous, but it was nice. She came over and she looked around, and I'll never forget her face. Her mouth just kind of dropped.... She was such a young, innocent girl. It took her breath away that I had my own place. I remember the feeling I got of [wanting] to take care of this little creature. You had to take her into your heart. It was really sweet. And she

said, 'Let's go where I like to go.' Downtown. She took me to this shooting gallery [a place where people could buy and use drugs]. I'd never been to a shooting gallery—never even heard of one. [Once we were there], she disappeared, and the people were from a completely different world. She knew the dark, strange, underworld of New York really well. I was slightly mystified by her."

Ryall then turns to the question that so many have raised: Did Gia really hate the fashion business? "No," Ryall says emphatically. "What we [all] had was kind of [an attitude that] 'This is work. This is awful. We're not materialistic.' There was this side of us that was vocal about the Establishment and not wanting to conform. We both had that, Gia and I. And I know Gia pretended she hated it all, and she put us down, but that was her. It was a concept she had formed of herself [or a projection] that people had planted in her, this dark idea: 'You're wild and crazy.' 'You're from the wrong side of the tracks.' All this stuff."

[At the same time], they were mystified by it and in love with it, because it brought another whole dynamic to every photograph.... Other people [would be] doing something normal, you know, like standing there, posing, looking cute or pretty or worrying about their hair. Then Gia would arrive [with] a growl, and she would throw herself into the scene! It was so exciting to be a part of that. So, in a weird way, that concept of her hating it all ... it was a dynamic that she created in the context of the art that she participated in. Because as an artist, I really see her as somebody who thought it through. She was smart and she was very intuitive. So she sensed right away where she belonged in that group [or where she] didn't. [She was] an outsider, like a great cult figure.

"Truthfully, I think she loved [the fashion business]. She really loved it. I think she pretended she wasn't [happy], but I think she was. I think she was seduced by that world. And she loved it because it was unknown and weird. The way she dealt with it was to hide within it and, sadly, there were also the drugs. It was hard to carry that light and [have] that attention on her.... It was kind of

... a curse. She wore the mark of Cain on her forehead. She stood out. She couldn't help that. She was extraordinary but, sadly, when she took me that night down into her world, I saw the beginnings of her way of coping with the discomfort of being thrown [in with] money and beauty that she didn't and couldn't relate to. She was really used and tossed around, in a sense. But that's how it was at that time. The girls were just used and thrown away."

If some consider Gia's sensitivity one of the greatest obstacles to her "survival" in the fascinating, stressful fashion business, Ryall has a different view. "She was just so beautiful, let's face it," Ryall says. "Her face was unusual, her way of moving was extraordinary, and that's exactly what [they] loved to photograph. I think her sensitivity, her artistic qualities, her ability, as I said, to become and exemplify the outsider—she realized how she was going to fit in or not fit in [and how she would be] seen and stand out—that was star quality. She recognized her difference right away, and what she did was to announce that difference and blow it up larger than life. I mean, it was like Marilyn Monroe. It had zero to do with being a model, really.... The trouble is that [there were] people who were phonies. They were conducting their business, and they didn't help people, and they didn't care. They were just grabbing.

"She didn't fit the mold of regular models. We showed up at nine o'clock and left at five o'clock and invested our money, bought an apartment. That wasn't her. I tried to help her a little bit, [but] she didn't want to know about that world. It was so uncool to her. In a great way, I totally respected her because she took herself to the [limit], and she ran with it. Did she throw it all away? Well, isn't that what she was supposed to do?

"I don't think she had a bad personality. I do think she was rebellious.... She wanted to be a star. And I loved her for that. She didn't talk about it. She wasn't saying nonsense in interviews. She was an artist. She'd be hiding in the corner, and then when you stuck her in front [of the camera], she'd flaunt it in every sense.

"Gia had this very sexual kind of [energy], kind of dark and

sexy, that they were not going to be able to control. And all the established people ... would put her down or fight her energy. I thought she was fun. I thought she was fascinating. I felt sad because she went too far with the drug thing and it killed her, but on the whole I thought she was amazing. She would probably have evolved into a great actress, if she had put her mind to it, because she had the capacity and brilliance and the 'vibe.' She was already acting. She was putting on the act of being this tough girl. She kept so many secrets inside of her, but when she looked into the lens, they all came out, and it was like, wow! She had a whole dark side going on and no one dealt with it. When she got in front of the camera, it was an explosion. It really was like Marilyn Monroe.

"We hung out together on the sets, and she just wouldn't conform. That's how it went. 'I don't like that, I don't like this.' She had her own way.... She was a wisecracker, but she wasn't loud.... She was known to disappear, but most of that, I think, was the drugs. She seemed so tender, so soft, so sweet, so internal because she'd been hiding so long. She had this beautiful body and so, when she [made her debut as a model], it was frightening to her. She had nowhere to go with it, but she went into this other, dark world where she thought she was safe. I was good friends with her. And nobody was really friends with Gia. I don't care what they say, she was a loner."

20

GERMAN ACCENT

G lenna Franklin, raised on the South Side of Chicago, made her name as a makeup artist among the luminaries of music, film, theatre, fashion, and photography. Her memories of Gia, she says, "are that she was a very conflicted person" and that she "liked to shock people."

Continues Franklin, "I kind of chalked it up to her being young, being a model, being beautiful, and getting so much attention so quickly in the business—[especially for someone] from a very modest upbringing, a very modest background, and being immediately internationally acclaimed.... I've seen it happen so many times in the course of my career, where somebody crashes and burns, and she was typical of that. As a model, she had a lot of charisma. If you assess her features and look at her face, she wasn't classically beautiful—but she emanated charisma and sex-appeal, and it was apparent she was born with it. That's what made her a great model, and [those qualities] translated on film. A lot of times you work with someone who looks amazing and the camera doesn't really love her. Well, the camera loved Gia! She exuded a smoldering sensuality that appealed to both men and women. She was charismatic, magnetic, and irreverent. You

were drawn to her and at the same time cautious around her. I believe she was aware of her power and enjoyed flaunting it. I think some of us lived vicariously through Gia.

"I do remember the first time we worked together. She was very young and new to fashion. I don't remember the exact year, but she had just flown from Paris [where she had worked] with Chris von Wangenheim. We did a test together, on the beach [in the Hamptons]. She had a jacket on and a great, natural look with her hair up. She was a new model and she wasn't getting paid, but obviously the agency needed some shots and told her she had to do it. So, we drove up in the photographer's [David Haas's] car. I was sitting with her in the back seat, and we talked. She was a little annoyed that she had to do the shoot," Franklin laughs.

In the photographs from that shoot, Gia seems to be sulking, though her decisive character remains visible behind the expression on her face. Says Franklin, "I was trying to explain to her that it was necessary [to do shoots like this], and I remember her saying very animatedly, 'Chris [von Wangenheim] said I shouldn't have to do this sort of thing because I'm already established,' but her agency must have insisted, so she was a tad resentful of wasting her time. I said, 'That might very well be, but we have to introduce you to the American market, and this is for your book, you know?' She was cursing. She was amazing.

"I remember very vividly that we stopped at a gas station. There was this kind of greasy, dirty man—the gas station attendant—and she looked at him and she looked at me, and she said, 'I love a man with dirty hands.' And I just said, 'You know, I'm not into that, but OK.' That was [her] 'dark' side, and when I saw that side of her, I thought, 'Oh yeah, we're going to walk on the wild-side for a little bit.'

"We did the job, and she was very nice with me and cooperative. I pretty much always tried to bond with models. She was being a little bit tough, but we got it done. Then years later I was working with Albert [Watson], and I heard she had become famous and was kind of making a comeback, and I think we did a

shoot with her [for] German *Vogue*. [That scene] was in the book and also in the movie about Gia. That's when we shot her on the motorcycle, wearing this beautiful outfit.

"I have to say," Franklin continues, "that Albert was a little bit frightened of her. I could tell because Albert wasn't shy, but he was very deferential to her. He treated her with kid gloves and she knew she 'had' him because I think she was that kind of person." At the end of the shoot, Gia asked Watson, "'Are we finished?' And he just said, 'Yes. Thank you very much. You were wonderful.' So she thanked him, got on the back of her motorcycle [still wearing] the outfit from the shoot, and she left. She had this [Claude] Montana leather outfit on, and she left. I was working with the hairdresser Kerry Warn, and [we] were watching with our mouths open. I said, 'Did she just leave with the clothes?' His only comment was, 'Fabulous!'"

Franklin laughs. "That's what I was talking about, you know? She was like that. People were saying she was a crap shoot, a roll of the dice. You'd either have a great day with her, a wonderful session, or you'd have a total disaster. You were taking a chance when you booked her, and that was her appeal. People kind of liked her for that. Also, at that time, nobody cared about the budget so much.

"I remember one shoot [we did] where we were all in a van on location. I was in the van with her. Albert had to be on the phone for quite a long time, and ... we were sitting in the van waiting for Albert, and she [got out] and was pacing, pacing back and forth like a wild animal. Pacing back and forth and talking to herself—and this is something I will never forget—in a very thick German accent. She didn't speak German, but she was talking and pacing and swearing with this heavy German accent.

"[Finally] I couldn't take it anymore, and I said, 'Gia, aren't you from Philadelphia?' And she said, 'Yes, but I have some German friends staying with me, and they're driving me insane.' [This was] toward the end of her career, at the end of her life, just before she disappeared and went back home.... But I remember it was

a hugely different shoot. It was harder to make her look good, harder to control her, and when she was pacing and talking to herself, and was totally impatient, you could tell she wasn't there with her mind. She finally stormed [off] and walked toward Central Park, which was maybe four blocks away, and she was gone for about thirty minutes or so, and then—aha!—she came back and she was totally fine. So you know what that means, right? But the good part of that story is that she actually came back. We did the shoot, and she was flying as high as a kite, and that was my most memorable Gia experience.

"I never got the impression she wanted to be anything else," Franklin adds with some doubt in her voice, "but I don't think she was particularly grateful [for] her career. My opinion is that it really didn't mean anything to her. Honestly, I don't think she was that enthusiastic about it, but when I worked with her, she always stayed at work and got the job done. Clearly she was being paid a lot of money, and I'm sure it was more money than she had ever seen in her life.

"But I wasn't in her inner circle of friends. [Ours] was more of a working relationship. I always talked about light stuff with her, like with all the other models. All I cared about was that she would be cooperative, so light talk, nothing serious. I had to get her to stay still so we could get going. I think she lived in her own world most of the time, and she seemed very uncomfortable around people. I think she was very introverted. She wouldn't talk about what was going on with her, in her world, especially not with me. But she was always nice to me at least. Thank God!" Franklin laughs.

"She wasn't abusive or mean like some of the other models. She wasn't nasty to people. I mean, I've worked with models who [were] all those things, and she wasn't like that. There was a very child-like quality about her, but [she was] also quite immature. She wasn't a shocking person. I mean she was simple when you got her going, meaning she didn't care about having attention, not in a cavalier way, and that was noticeable. It was very inter-

esting to watch her interact with Albert Watson. It truly was clear to me that Albert was afraid of her. Because she really didn't care and, given her personality, everyone was concerned she would screw up the entire shoot. There was always that very delicate balance with her, all the time, like walking on an edge: 'What's next?' 'Cross your fingers.' But I guess that's why people kept her around them, because she was like that."

Franklin realized early on that something was wrong in Gia's life. "She was kind of rough and tough," she recalls. "I mean, there was a toughness to her, but I almost felt it was a façade— how do I say this—maybe like a shield to keep people away. She put up this wall of being tough—that's what I felt. But I thought she was fragile. I think that was her defense strategy, and it is how she crumbled at the end. She just crumbled. She must have gone through so much. She was at the brink of embracing some of her success, but she couldn't allow herself to embrace it because of her sense of self-worth. She didn't like herself very much, obviously. Because you don't look at yourself with that kind of a face and just throw it away. I think there were a lot of problems with her psychologically."

Recalling the incident with the David Haas test in the Hamptons, Franklin returns to her memory of Gia "with that expression on her face because of how she felt [about doing] that test. There was this sadness she was hiding, and yet she was able to pull off this look and have people want her. But she wasn't psychologically or emotionally prepared for it either. It's very sad, but I have seen it happen to other models. Still, she was the one that, for some reason, everybody wanted because her expressions could be and were so dramatic. I can say that from the moment I met her, I knew she was special. She had a gift, and I remember feeling sad that she didn't nurture that gift and that she threw her life away. When I saw her at the end of her career, it was heartbreaking."

21

HEART OF GOLD

Gia Carangi demonstrated her heart of gold on a daily basis—in the things she did and said, on the set and elsewhere, and especially in the enormous sensitivity she showed toward people who were in trouble. It didn't matter why. Photographer Alan Kleinberg worked with Gia only once, but he recalls her as "a great lady ... with a great smile." Kleinberg continues, "I remember she was stunning, and she looked like a movie actress. She was very simple and different from all the other models."

Kleinberg noticed no difficulties in Gia's interactions with others. "She was very social," he says, "and she communicated with her friends. You could tell she had a great heart [because] she would speak with and be nice to everyone who talked to her. She got the job done.... I think she was [happy doing modeling]. I mean, she was great at it. It's not up to me to say if she was happy or not, but.... She took direction well. I know she stumbled into fashion and, when I saw her on a runway, she performed very well, like no one else did. She was very natural. She had a look, and she would become this stunning lady, stunning model. [On that particular shoot], we were working for a fashion magazine, and there were a

lot of people and models around, and she would talk to and smile at everyone. I remember passing her in the hallway. She was very polite, and you could tell she had a great sense of humor.

"She had moments when she was alone and thinking, but I think that's normal. If she was introverted, maybe [it was the way] we all [are at times]. I know there were problems after [we worked together], but she was really friendly with everybody [on that job].... I never had the impression she had problems. From what I experienced, she had a great mood and was smiling all the time. She was a girl from Philadelphia and made it big. Everybody wanted to work with her. [She worked with] *Vogue* a lot, and she travelled a lot. Then, as you know, she got into drugs. I believe if she hadn't, if she [had stayed in the business], she would have become a great actress.

"I remember she was smiling at everybody [and that] she was very supportive of others, and I [saw] that she cared for people. She truly did. I remember if someone screamed at a model, Gia would make fun of the photographer or whoever and make faces behind his back. She'd talk to the model and be there for her. Put her arms around her and make her feel better. I remember there was also a [male] model, and she joked a lot with him. I believe he had problems, but she [made] him feel better. She would goof around a lot, kind of be a joker. She wasn't like the others, I'm telling you. She was very simple and very low-key and she cared for everybody. I can tell you she had a great heart."

The noted public-relations representative, Matthew Rich, called decades-old memories to mind in his recollections of Gia. "I met her in Harvard Square in 1977 when I was in law school there," Rich said. "A model friend introduced us. Beautiful, in a word. She was sweet, loving and giving, inside and out. She was one of the few models whose core personality equated with her external beauty. She was a closed, private person. I think she [had been] that way since childhood. [My impression is that] she would have loved to do almost anything else. I think she wanted to be a newspaper delivery boy! She laughed at how serious other models

took themselves. I always thought she considered [modeling] a stepping stone to somewhere else. Of course, this was all before she began experimenting with drugs. We went lipstick shopping once.... She kept saying to the counter girls at Bloomingdale's and Bergdorf's that she wanted 'blood red.' At one point she pricked her finger and said, 'This color!' Of course, we were dressed like hippies and it didn't look like we belonged in those places."

Joe Petrellis, one of Gia's closest friends, recalls the model's generosity above all other qualities. "She was one of the sweetest girls in the world, and she always loved me. We were very, very tight. When I went through my divorce, she was there.... I saw her a lot [around] 1979, before she was a superstar. And I would see her a lot, too, after my divorce. Gia was very quiet, very reserved, and very generous. When she came to my house, she would always bring me flowers. She was always a very concerned person, a very giving person."

The same concern for others impressed Lisa Ryall as well. "[Her] money was going to everybody she loved," Ryall says. "She was giving it away, taking care of people. She had a big heart. She didn't think of herself."

"She would share," Petrellis added. "She would loan her car out. She was a good person, believe me. Her stepfather, Henry Sperr, was my accountant, and that's how I met her. And that was it. She got along pretty good with him. But you know how stepchildren are; they always fight with their stepfather. Gia hung out with the wrong people. She hung out with rock stars, people [into drugs]. I'm sure of it."

Even as Gia's star was rising in the fashion industry, Petrellis continued to spend time with her, and their relationship remained unchanged even after Gia became successful. "I would speak with her when she was here," Petrellis says. "And I would take her to fine restaurants. We were dear friends. I shot her, too. I have pictures of her at my house. I photographed her at my house, and my wife was there, too. My wife was a big model— Betty Harren. She did covers. I wasn't into that. I took Gia the

way she was. A beautiful person. We were very close. She helped me forget what I was going through in life, during and after my divorce. She helped me through it. She was a very giving person. But she wasn't happy with her life!

"She was also into women ... she didn't know what the hell she was! I'm not a psychiatrist. I'm just a photographer, and I made my money with my eyes. Sometimes you can't just figure people out. [At the end of her life], I was the only real friend there. There were none of the photographers, no models were there. Do you understand? They stayed away from her! She had two real friends: me and Rob Fay! We were the friends."

Petrellis recalls a particular anecdote that illustrates Gia's thoughtfulness: "I was in the hospital with kidney stones after my divorce, and Gia found out about it. But she knew I liked gardenias. So I'm in excruciating pain in the hospital with kidney stones, and a black woman walks in with a big bouquet of gardenias. There was a note that said, 'Get well. I love you, Gia,' and the woman said, 'Mr. Joey, you must be very important.' You know what I'm saying? It was one of the nicest things she ever did for me. I used to loan her money, and she always paid me back! I knew she was doing drugs, and I used to talk to her: 'You've got to get some help! You can't go on like this! You can't!' Everybody told her! Not just me. Her stepfather and mother couldn't control her. She did what she wanted to do. When she was starting to get into the real upscale modelling, I used to go stay with her. I was like home [for her]."

Petrellis also recalls a particularly happy day that he and Gia spent with a mutual friend. "We were at Mikey Dimple's [in 1981]," Petrellis says. "He was a character in Philadelphia. I had a Rolls Royce then, right? Mikey Dimple lived in a very poor part of Philadelphia, but he had a beautiful little house. I parked the Rolls out in front of, and [Gia and I] went to see him. There must have been about fifty kids around that car because they'd never seen a car like that in the neighborhood. Mikey was a character. When he came downstairs, he was [wearing] a funny hat, and ...

playing this fancy trombone. He didn't play any melody—he was just blowing it. Gia laughed so much she had to go to the bathroom. That was a very funny day. Mikey made lunch [for us], and it was a beautiful day.

"We used to go up to New Hope [a town about halfway between New York City and Philadelphia] together. She loved to hang out in the second-hand shops. Gia had her own style. She did breakthroughs in New York. People copied her—girls copied Gia. She was a role model. She was. She loved me and I loved her. That should tell you everything. She loved my company. I always treated her to the best. I never had to buy her presents or any of that. We used to go into New Hope, and she liked to visit thrift stores. She liked vintage clothing, and she would buy a man's blazer, and she would put [an outfit] together with a necktie or a shirt. She looked good! And all the girls in New York were following her. Worldwide, even when she went to Italy! They loved her! She had that personality, that sparkle. In my eyes, she wasn't a raving beauty. She was no Grace Kelly, she was no Nicole Kidman, she was none of them. She was more buxom. She had unbelievable, beautiful breasts, gorgeous, and they stood up, but they were big! A lot of models had nothing! Gia's personality made Gia. She photographed well, and she worked only with the best guys. You'll see in the early pictures how clean that was. You can see the sadness in her eyes and how true she was. Impeccable girl. You see [models] with frowns on their faces. They're unhappy and angry. Gia was unhappy, but she wasn't angry. It's different! If I was walking with her and there were beggars on the streets, she would give everyone a dollar. And if she didn't have money, sometimes she'd say, 'Give me a few dollars!' I'd give her the few dollars, and she'd give them to the beggars! She had a heart of gold. And I think her heart of gold could have contributed to destroying her. She would hang out with strange people that nobody wanted to associate with. Probably at the beginning she felt sorry for them, and that was her!"

22

FUR COAT

New York City photographer Steve Prezant worked with the beautiful Gia only once, but that single experience made a significant impression on him. "She had a terrific look," Prezant recalled. "She also had a reputation as what they would now call a supermodel. At the time she was one of the stars in New York. [The photo shoot] was for a client called Christie Brothers. They wanted an ad for the *New York Times* and some other magazines, and she was one of the models. It was one of those shoots where you went out all day on location, and it was nice. I mean, it was different. She was a young girl [surrounded by the other] models, the crew, the hair and makeup people.... I was setting up the lighting on the location and, when we were ready, we would call whichever model or the one we chose for that particular scenario.... She was so nice, though she was also being kind of difficult in her way.

"She was very much in demand, and she knew that, but [unlike other] well-known, in-demand models in my experience, she didn't really like taking directions," laughs Prezant. "It's not like she did it on purpose, but it's like a champion baseball player in America or a famous soccer player in Italy. She had an attitude

like, 'I didn't get famous because I listened to you. I got famous because of what I do and the way I do it.' And I don't think that was really anything bad. You've got to remember, when I worked with her, she was maybe eighteen or nineteen. [Looking back from the perspective of my age now], she was a baby, she was a kid. When I said to her: 'Do this or do that,' she would sort of try to do it, but she did it in her own way.

"There was another model there, Anna Anderson. She was older [than Gia]. She did what was asked of her, and [she did it] like a commercial model: 'I'm doing this for the money, and when I'm done, I'm done. I'll take the money I earned by doing what you asked.' [She and Gia] had two different approaches, and that's what I remember. If I asked Gia to do something ... it's not that she wouldn't do it, but she wouldn't do it exactly the way I wanted, and her attitude was that she [wasn't going to] give me what I wanted but rather what she wanted."

On one occasion, Prezant recalls, Gia was asked to model fur coats. "The truth is that fur coats like that were made for older women," he says. "Gia was young, and she wasn't a huge, tall girl. She wasn't like the models of today that are six feet tall, and she couldn't wear a fur like that.... I mean, for a fur ad, a woman has to have a lot of stature. Those furs were not made for women like Gia. She wasn't tall enough, but the client wanted her.

"Commercial work is about the clothing, and [the job] was to make sure she looked great in the clothing. They tried, in a way, to get rid of her wildness, to tone down her hair and not give her extravagant makeup. She had to look like she [was someone who would] wear a mink coat," Prezant laughs. "They were trying to sell that [product], and they wanted to have sexy images but toned down, with the models accentuating the furs. But I don't think that what I shot was like that. So in editorial, they edited the photos.

Prezant expands on his recollection of Gia's behavior on the set. "She wasn't rude," he affirms. "She was like young kids are, a little loose. It seemed she didn't care about the client, but she

wasn't rude. She was a big child: she was there, making some money and having a good time, and that was that.

"I think she was just thrown into it. She was very pretty and very sexy, and [there was a lot of] demand for [what she had] ... because she was different. She could make money quickly.... Gia wasn't blond, and she had that difference. She had a sexy look, and I don't think it was what she wanted but, like I said, she got thrown into it. She saw that people liked her look, and she found out that was a way she could make money, and that was it. That was my impression. Maybe she [would have liked] music or other things better. I think [modeling] was just an easy way to make a lot of money, and people really wanted her because she was different from other models, and [despite her behavior], she could get away with a lot. She knew that. At that time, you could get away with a lot more [in general]. Today, the model and the client are much more, in a sense, business-oriented. And that goes not only for the models, but includes photographers, too. [At the time], you had the client and the art director, and you just did it. Nowadays they watch everything you do, but not then. What I'm saying is that she was really nice, but her attitude wasn't, 'I need the money to further my career.' It was [closer to], 'I'm Gia. I'm here to make money, and I [happened to] fall into this [line of work]. Later I want to go home and go to a club.' She was different from all the other models I worked with at the time. She was the one who had a different mindset. The others were into their careers, but she gave the impression she wasn't. That it was for the money. The client might be looking at her and thinking, 'What is she bringing to the table?' And then you shot her and you'd see the photo, and if you got her in 'the moment,' it was her. It was just her. What she brought to the table was herself. That's who she was."

Returning to his memories of his experience with Gia on location for the Christie Brothers shoot, Prezant recalls that "one of the male models [Bob Menna] had a great, good-looking Mercedes convertible. I think that he, Gia, and maybe someone else

were in the car, and the rest of us [drove] in the location van with all the equipment, the assistants, the clients, and all the rest. So when we got to the location, the [models] went into a house [to do] makeup and hair and clothing, and me and my crew were in an RV. I would go into and check on makeup and hair and say, 'Come on. We've got five minutes.' That's how it was. It was loose, but that's how it sort of worked. There was no animosity it all. She would get a little grin on her face, or mock in a way, but it was loose. The people that I brought in were terrific, nice guys. The makeup artist was Harie von Wijnberge, a really nice guy, and everybody had a really great sense of humor. Everybody was very relaxed—with the exception of the art director who was constantly on my back saying, 'Come on, come on, come on' [laughs]. The models [weren't paying much attention to him] because it was [otherwise] so relaxed and loose, so he would come to me and ask me to go to the models and say, 'Come on, it's getting late and we have a lot of shots to do.'

"While we were shooting, if I recall well, she might have wandered into the woods between shots. We had different models doing different things, and they all had down time, and I think she just wandered off in the woods to take a walk. Because it's not like nowadays where you have people on your case between shots. You'd have maybe an hour waiting or something like that. I don't know what went through her mind, but I think she just went for a walk to some nice place to sit in the woods, and then she came back.

"This was just a one-day shoot, and we didn't have time to sit down and socialize or chat over dinner, you know? [But my impression is that] she was just very nice, very sweet, and she seemed, in a way innocent—what is the word, 'simpatico.' There was something vulnerable about her. She was young. If you looked in her eyes, [you'd see] a sort of vulnerability. But [in terms of drugs], no one did anything out in the open in that shoot. We were all together with the client and it was tighter [on the set].

"I remember one thing that was funny, in a way. There was

this one shot, and I think Bob Menna and Anna Anderson were there [as well as] someone by the name of Brad Olsen-Ecker. He was the creative director, and he was the one always whispering in my ear, 'Come on, come on, come on.' [The concept was to put Gia] on a step. She was [supposed to step] down and jump into the [male] model's arms. It was sort of corny because he sort of had his arms down, and she was supposed to leap into his arms, and he was supposed to grab her, but the shoot was intended to capture the execution of the leap. It was weird because she was wearing a mink coat, and she was hard to catch. It took a while to get it done the way the director wanted it, and we shot lots and lots of leaps [laughs]. It was a very easy [movement] really, but the logistics of setting the shot up [were not]. Gia had to be at a certain distance where you wanted her to leap off the step, but then when she leaped, she went crashing into him. It was sort of funny, establishing that shot until it worked.

"From what I remember, she was a lovely sweet young girl. I mean, I didn't know her that well, but [in terms of what I saw] working with her that day, she was very nice. Honestly, I saw her being her. I was a very busy commercial photographer at that time, and I was working a lot.... I mean, if it weren't for Gia or some of the other people, it would have been just another shoot for me.... I worked quite a lot with Harie [von Wijnberge] in those days. He was excellent.... She was a sweetheart, and she might have had some issues, but who didn't have them?

"To me a big issue that is still prevalent in the industry— whether it's film or photography or fashion—is that these young people get there, and it is very, very hard for them to be like normal kids, like normal people. The bottom line is that Gia was a normal person, but things happened to her so fast—too fast— [and she'd had] no education about how to handle success."

23

A DAY IN THE FOREST

The day that Steve Prezant recalled wasn't the only shoot that Harie von Wijnberge did with Gia, however. "I found her a very sweet and lovely girl," von Wijnberge says. "I did a *New York Times* story with her in a bath tub, and Denis Piel taking pics of Gia in the bath. . I did the hair and makeup, but I didn't use a waterproof base coat, so I had to do it all over. She could not have been nicer. It was my fault, and other girls may not have been so lovely."

Von Wijnberge also remembers the "day in the forest" when Gia wandered away from the set. He recounts, "Another time I did a fur campaign with her, Anna Anderson, Bitten [Knudsen], and Bob Menna. It was a day in the forest and we had great weather. However, our sweet Gia wandered off. It took a few hours to find her again. Bob Menna found her just in time. The clients were very pleasant, as she was their choice! We thought it was hilarious and she must have as well.

"I worked with Scavullo, who adored her, and his studio felt very safe. We all adored working there! There was never any problem with Gia. I did feel that she was unhappy and not as 'into' being a model as most. I liked that about her and would

never have held that against anyone. It is rather unpleasant to be fussed over and liked solely for your looks. Being a model must have been a torture for her! I would take her any day over the Cindys, Lindas, and Naomis. So nothing but praise and kind feeling towards her."

Bob Menna, too, recalls the fur-coat shoot. He says, "We were not best friends, but we would joke around quite a bit. I remember once we were in the woods, I think in New York or New Jersey, a beautiful place. We had down time, and we were all joking with each other as usual. I remember an assistant came and screamed at us to get going. One of the models got upset, and Gia went to reassure her. I have no idea what they said to each other, but after that every time she saw that guy, she would make faces and make fun of him behind his back ... and that was Gia. She always did that. If you were her friend, she would protect you like a mother hen. I remember that shoot was for a fur coat, and Gia made a comment that she would never buy something like that. I think we had to do some stunts, but in the end it all went well."

Recalling the story of Gia's walk in the woods during the shoot, Menna reflects, "Sometimes we all have our [private] thoughts, or maybe we want to be alone, but I don't remember why she would have taken off. I don't remember her even disappearing, but Gia was the kind of girl who would do that. She was very independent. I never worried about what she would do or where she would go. She was a strong person in my eyes, [based on] what I knew of her and what I had experienced with her." Later, Menna's memory of that day came back more clearly. "I do remember why Gia walked off the set that day," he says. "I don't know what exactly, but she was upset about something. It might have been family related or something else.

"She got along well with everyone. Everybody liked her— also because she truly was a supermodel, and people wanted to be friends with her. Whether they were honest or not, I don't know, but I'm pretty sure she had a good relationship with Bit-

ten. You know, when we were together [in the woods], she had no problems communicating. She was chit-chatting and making fun of people most of the time. Sometime she would spend time alone looking at magazines or reading books, but she got along quite well with everyone. I didn't see any problem. She was an incredible human being, spontaneous, a tomboy with a twist of feminine. No one else was able to do what she was able to do. Definitely, she was a special person. And you picked up on that instantly."

24

ELITE

Gia's career very nearly came to an end in 1981. It was Sasha Borodulin who came to her rescue and allowed her to continue working. Through his friendship with Monique Pillard, he managed to secure a major opportunity for a struggling Gia.

In their early days of their relationship, Borodulin says, "we had a great time together. We were in love, first of all, and we were also doing our best to be as cool as possible. Gia was so magnetic that all the top female models fell into her orbit. She'd bring them to me, and then she'd ask me, 'Why aren't you sleeping with that girl? Why aren't you sleeping with that other one?' Those girls did everything Gia told them to. So all of a sudden I had all these beautiful women around—top models or 'semi-top.' She led them to me and then she'd stand back to see what would happen. She got a kick out of it."

But by 1981, Borodulin says, "things had changed. It wasn't working anymore. So I went to Philadelphia, where I met Gia's mother. I told Gia, 'Come back to New York, and I'll help you get your modeling career back on track. What in God's name are you doing here? You don't have any money. Get out of Philadel-

phia.' And she said, 'I'm afraid.' I told her, 'I'll help you. Come back with me and I'll help—but only if you feel strong enough and if you agree to do exactly as I say.' And she agreed.

"I took her to Elite [Model Management] because I had friends there, and I had her meet with Monique Pillard in person. [Monique] was a very kind person and a good friend. She and I went off into another room, and she asked me, 'Sasha, do you really think she's off drugs?' I said she was—because, at the time, she really had quit. Then [Monique and I] met with John Casablancas, and the three of us talked. They didn't want to take her on because they were afraid of her. The modeling business isn't about friends; it's a business. The female models who work for agencies are employees, in a certain way, and who wants an employee who shows up for a photo shoot and then leaves in the middle of it, or doesn't show up at all, or who comes late and then falls asleep on the set? And that's the kind of employee Gia was at the time.

"They weren't concerned about Gia's well-being, and it really wasn't their job to be—they weren't her family. As I say, modeling agencies may seem cold, and you can criticize them for that, but modeling agencies don't exist to provide social services to young women in the business. They're workplaces. A modeling agent isn't a personal assistant or a personal manager. He or she is an agent with twenty-five, thirty models to deal with, and that's how it works. The agent's job isn't to stand by the model's side and take her around to photo shoots and so forth. There are people who do that kind of job, but in the movie business—not in modeling. So they're not concerned about the models' health or how their lives are going. They couldn't care less. They're worried about their relationships with their clients because if the agent sends a model to a client, and the model screws everything up, then the agent has a problem.

"I had to vouch for Gia because they didn't want to take her on. I said, 'I will personally see to this,' idiot that I am. And then, of course, she started using drugs again. She wouldn't live with me, and I had no idea what the hell she was doing. So that's when

exploitation? That's a worse kind of exploitation than being a model who appears in a magazine and gets paid to do it."

Still, a large number of fashion insiders would disagree. They continue to implicate agents, bookers, and editors as complicit in the evils of the fashion industry—both in Gia's day and now. These critics of the fashion business often view such figures as unscrupulous, interested solely in profit, and unwilling to see the young female models they work with as human beings. There was one booker at Elite, however, who stood out for her dedication to her profession and for the empathy and compassion she brought to her relationships with the female models in Elite's "stable": Patty Sicular. Today, Sicular directs the prestigious "IconicFocus" and "Legends Division" at Trump Models, but more than thirty years ago, Gia was one of "her" girls. Sicular lavished time and attention on Gia, hoping until the very last that she would get her life back on track.

Sicular recalls, "In the 1980s, all the new bookers got the difficult models that no one wanted to handle, and that's how I inherited Gia. I inherited her, but I always liked her. She was always respectful to me.... She was a sweet kid, and I really liked her. She was always like a baby bird, and so I tried to give her extra attention. You know, as an agent, I'm almost like a mother or an aunt or a sister to these people. If you have children of your own, you might have ten children and one of them needs more attention in certain ways. And she was the one who needed more attention, aside from just booking."

Sicular says she "didn't think Gia loved modeling because she would always disappear. Every time I took a booking, I thought, 'Oh, my God. We're going to go through it again.' Everyone knew she would disappear. Usually, bookings would be eight hours a day—nine to five, say—and every day by noon or one, I'd get the phone call: 'Where's Gia?' She'd jump out of a window. She'd do whatever. But every day: 'Where's Gia?' And yet Gia was so extraordinary, they would always hire her again. But it was always, 'Where's Gia?'

"I guess her way of jumping out the window and leaving all the time was kind of funny. We all sometimes feel that we don't want to be somewhere, and she was cool enough to go 'I'm outta here' and just leave.

"You know, I really adored her. She wanted to like me because I think a lot of people didn't appreciate her, and I wasn't like that. But she was also a naughty child sometimes. I wanted her to do the right thing by her—not by me but by *her*—for her health, and she would react like a child and say, 'I don't want to do that.' I tried to force her to do the right thing, and it was boring, you know? And we worked at that process. We'd have to go out for a walk around the block at four o'clock in the afternoon, which is the time when bookers are busiest getting their bookings for the next day out to their models.... I would try to talk to her and show her the right thing to do.

"I was [at Elite] until, I believe, about 1983. Then I quit—not because of Gia—and I worked for Club Med. After that, I moved to the Ford Models' high board, got married, and left the business.... I didn't know Gia was sick. If I'd known she was sick, I'd have gone to visit her. But I do want to say that Monique tried to help [Gia]. Monique tried to get her into this center that a lot of the top agencies sent their models to [for help]. But she wouldn't go.... I do know Monique really, really tried to help her."

Sicular recalls giving Gia a gift one Christmas that apparently surprised the supermodel. "I didn't make a lot of money, but I handled sixteen models [including] Gia, and [I wanted to give them all] Christmas stockings. I filled them with gifts that were red and green for the holidays—hairbrushes, soaps, sunglasses, toothbrushes, candy canes, and things like that. I remember when I gave [the stocking] to Gia. I don't know whether she was shocked that I gave her a gift or shocked that it was so geeky, but she looked ... puzzled. I don't know if that was the type of gift she wanted, but I gave it to her."

Gia and Sicular spoke every single day, and Sicular tried to give the best advice possible, hoping it would help. "I have to be

honest," Sicular says. "Usually when we had a conversation, it was me—I don't want to use the word 'yelling.' A normal person would have been yelling at her, but it was, 'Take care of yourself. Eat right.' Or I'd be chastising her about some infraction.... People say the business chewed her up, but I think people are the same whether they are living in New York City as a model, or living in the Midwest as a librarian."

Eva Voorhees, the celebrated former model and Gia's contemporary, witnessed the extent of drug use in the fashion industry first-hand, though she points out that not everyone partook. "There is a myth that everybody [in the business] used drugs," Voorhees says, "and I'd like to dispel that because I didn't. I was Miss Health Food Fanatic, and I brought my brown rice and other health stuff to the job site, and people thought I was insane."

At the same time, Voorhees acknowledges that "in 1978 or 1979 or 1981, people talked about cocaine all the time. I didn't use drugs... but people were using drugs in the studio—the hairdresser, the makeup people—I mean, it was just there! And at any point, an agent could have done something about it! Or a photographer could have done something about it! There was a whole, cumulative group of people saying, 'We refuse to discuss anything.'"

Still, drug use per se was not, in Voorhees's view, necessarily the crux of the matter. "When I was modeling," she says, "no one, no agent, ever said, 'Look, you are going to be making a ton of money'—meaning, you are going to go from being a waitress in a little coffee shop to making 2500 dollars a day. How are you going to deal with that, and who is going to manage your money? Who is going to take care of you and teach you to manage your money and life? Not one single agent ever took any model aside and said, 'These are the things you've got to look out for. You need to get an accountant. You need to get a lawyer.'

"[There were] caring, honest people in the business. There were a lot of good people. I have been lucky [because] I never worked with the sleazy people that you hear stories about. Sending models out for a booking, and there is no booking—just

some man that wanted sex. Oh, yeah. That happened quite often. So I was really lucky...."

The point is not, Voorhees concludes, to try to argue that "back in the seventies, nobody cared about anybody.' That's ridiculous!" And yet, she says, "I think there was a lot of *denial* at that time [about drug abuse]. They knew, but they *ignored* it. Maybe the modeling industry just sort of ... looked the other way. Not too many people had the back-bone or conviction to speak out."

25

GOD HELPS THOSE
WHO HELP THEMSELVES

"How can I help Gia?" That was the question on many minds as friends and colleagues helplessly witnessed Gia's descent into the abyss. Unfortunately, the question was often more the result of an emotional reaction than of rational thought. Those who had Gia's destiny clear in their minds did the best they could, but none of them had the skills to provide her with what she really needed. In the end, there was only one person who could have guided Gia out of the hellish tunnel her life had become: Gia herself. And doing so meant a tough, uphill climb—quit denying there was a problem, start being willing to accept help. To make that happen, Gia became fragile, and she was able to get clean, at least for a time, by humbling herself. No one who hasn't been on the same road can understand what that must have cost her. She entered rehab, knowing full well that she'd need to put body, soul, and an immense dose of willpower into the process of getting better. Those who wanted to help from "outside" genuinely didn't know what to do or how to do it. Others wandered away, stopped seeing her, but Gia's drug addiction was in plain view to most of the

fashion industry. Sadly, she was hardly a unique case. Drug addiction had become a widespread social scourge, and Gia and her problems—in that ocean of people in the same situation—easily became secondary. Whether it was the result of Gia's disastrous choices or a vicious quirk of fate, Gia's drug addiction provides the opportunity to reflect deeply. In the process, our personal convictions and experiences may well be shaken.

Bob Menna notes that people often spoke (and speak) of Gia "as a lost soul, as troubled. I dislike those labels because they don't accurately describe her," Menna says. "Of course, when drugs, alcohol, or other extreme [behaviors] take over a person's life, the person is not to blame. Others who need to find a definitive explanation for [the] behavior label it in order to feel safer themselves. As I see it, we are all potential Gias. I put some blame squarely on the industry itself for enabling this sort of behavior [especially common at that time]. No one had the guts or ethics to tell the girls or guys in trouble that they would drop them if they didn't clean up. They [kept quiet] for selfish reasons, because they knew another agency would just pick [the model] up. Rather than send them to rehab or to get some sort of help, they sent limos to their houses to get them to work when they were late, even when they knew their lateness was due to drug or alcohol abuse."

Menna also recalls the famous fashion photographer Francesco Scavullo and his concern for Gia. "Scavullo's studio was in my immediate neighborhood, and we got our hair cut at the same place, so I would often run into him. He truly cared for Gia and was heartbroken about her descent into darkness. He, too, was tortured by 'What can I do?' I think it's a fair subject to bring up, especially since it hasn't been done before, at least not to my knowledge. I do put partial blame on the agencies, editors, photographers, art directors. There was always such a rush to get the next hottest girl or guy to sell their product, be it a magazine or bottle of perfume or liquor. While I understand that millions and actually billions of dollars depend on it, I have always felt that those who benefit directly from the work have some obli-

gation [to the models]. They could and should have done more to protect the ones who produced those benefits for them. That was one of my reasons for going over to the other side of the industry, which I was eventually successful with."

Menna goes so far as to compare the modeling industry to a kind of cult, noting that he has since dedicated himself to learning about "the dynamics and methods used to keep [people] involved in those kinds of organizations, and I've acted as a consultant to those involved and their families. Looking back, the modeling industry wasn't very different in those days. In most cults, it's all about the dollars. In a few, the leaders are only interested in the power they hold over the members, but in most cases, they need the money to continue. If a cult member gets sick [and] can no longer produce income for the group, recruit more members, or otherwise [becomes] bad PR, [that member] is cast out—not by [being] kicked out, but [through] a slow pulling away of support."

Albert Watson, the award-winning fashion photographer, holds a more traditional view of the business relationship between models and other professionals involved in the world of high fashion. "When someone has a drug problem and you are working with [him or her], there can always be problems," he says. "Like if the person doesn't turn up. Now, to a lot of people outside the fashion business, the fashion business seems kind of funny and a bit sloppy and silly, which it sometimes can be. It can be, but at other times, because of the sums of money involved, it can be brutally professional at the same time. When you are paying the photographer twenty-five thousand dollars a day and the photographer recommends a model, and you agree to pay the model ten thousand dollars or more, and you have hairdressers that are booked, makeup artists that are booked, studios that are booked, equipment that is booked, it can be a very costly thing if the model doesn't turn-up. This is quite important to emphasize because a lot of people say, 'Oh, she didn't turn up. That's pretty bad. OK, let's move on!' But what you don't realize is that the

repercussions when somebody doesn't turn up can very easily be fifty, sixty, seventy thousand dollars."

If, from an artistic point of view, the lack of supervision may be an advantage—think of the cliché of the eccentric genius—in everyday life it can become a problem for everyone. "Gia was completely undisciplined," Watson says bluntly. "Unfortunately, when you are dealing with a drug problem, those two factors together—lack of discipline and drugs—it's a dangerous mix."

Watson continues: "I've known people on drugs who eventually said 'I've had enough' and dropped out of the drug scene. She wasn't one of those people. She was definitely on a downward spiral, and I could feel that, but there wasn't a lot you could do. The fashion business was really an enabler. She could make large sums of money very quickly, and [in that sense] the fashion business is a very strong enabler. There are a lot of people who have to [punch the clock] at nine in the morning, and they have to work until 5:30, and they get an hour for lunch. If they walk in at 9:20, [someone says], 'Oh, you're late!' They work all year to make a salary of fifty, sixty thousand a year, if they have a decent job. Sometimes Gia could work for three days and make fifteen, twenty thousand dollars. So that didn't help her situation. If you make twenty thousand dollars or you have twenty thousand dollars in the bank, then of course you don't need to work next week. You can say, 'I don't want to work for three weeks. I'll take a holiday, or I'll just go to my apartment and do drugs.' So the business didn't help that. The fashion business and the music business are similar in a way, I think. I don't know whether there are more drugs in the fashion business than in the music business [but] that might be kind of an interesting thing to find out."

Watson's reflections take a personal turn when he notes that, having "been around drugs my entire life, I was never, ever, ever [tempted]. Drugs, to me, are a cup of tea at four o'clock in the afternoon. You make decisions in life. Sometimes the situation is bad, but it's your choice. You want a cigarette, you smoke cigarettes. People tell you cigarettes will kill you, and you still smoke.

Or you get drunk [and drive] a motorbike into a brick wall at a hundred miles an hour, and you die. And so if you choose drugs, then you've chosen it. If somebody kidnaps you and puts you in a basement and forces heroin into your veins, then that's a different story. But if you choose that lifestyle and you choose [to pay] somebody who gives you drugs, [it's a decision]. I basically don't like the drug scene. I don't drink or anything like that, so, in a weird way, I was on the other side.

"People sometimes say, 'Well, why didn't you help her? Couldn't you help her?' [My response is], if I'm crossing the street, and there's a little old lady in front of me—just to exaggerate a little—and she trips and falls down, I will immediately help her up, and say 'Are you okay?' or help her with her bag."

And yet, Watson continues, "help" in the context of professional fashion shoot—and in the context of Gia's specific "fall"—meant something entirely different. "It's not [as though] you sit back at the end of a shoot and chat. You don't sit down and say, 'Oh Gia, why don't you stay behind a little bit, and we'll chat about your drug problems?' If you really know drugs, things don't work that way. You don't sit down and chat with somebody and say, 'There we go. I solved your problems.' It doesn't work that way. Drug problems have to be solved by the individual. Of course, [if you] go into a drug rehabilitation center, and if they're strict, then you're putting yourself into isolation. And of course you can chat with people who can help you get through the day, the week, the month. But if you are really prone and you have a lack of discipline, [when you leave that environment] there's always a great danger that you're going to slip back into it.... Sometimes people say, 'Oh, you couldn't help her?' What do you mean help her? It's almost silly to say that. Drugs are a chemical thing and [susceptibility] depends on genetics. [You need] the persona to deal with [addiction], but even people who have discipline ... drugs break down discipline. So you can be a very disciplined person, and the drugs can suck you right in.

"The only real way [not] to get involved with drugs is never

to come near them. Like Studio 54—dancing, cocaine. 'Oh, that was good. I loved that!' That's the lure, and then it's just a spiral.... I don't condemn anybody else. It's up to them what they do with their life. But then, of course, if the whole studio's waiting for you, and you do drugs all night, and you can't make it into the job the next morning, then what you do is affecting other people. If Gia had saved up a hundred thousand dollars and decided, I'm going into the mountains to a cabin where I can do drugs for two years, then she wouldn't have been affecting anybody.... But the minute it begins to affect other people, then it's a problem."

Many of those who knew Gia described her as mysterious, inscrutable, disinclined to talk about herself, even with the close friends she made when she first arrived in New York City in February of 1978 (though there were some obvious exceptions). In general, however, Gia didn't talk about herself much and didn't share her confidences lightly, especially if she didn't have the sense she could fully trust the other person. As Suzanne Rodier recalls Gia, such diffidence had been her constant companion for years. "She rarely trusted anyone," Rodier says.

If Gia wasn't one for long flights of eloquence, when she did speak, she was direct and to the point. Her words made her humility and simplicity clear to anyone who heard her, and she was sincerely appreciated for those qualities by even the biggest and most cultured men and women in the fashion industry. The few times when Gia would strike up a conversation in the dressing room or while she was being made up, she tended to keep the conversation light, just a few sentences to help pass the time. Kim Charlton, however, recalls one time when Gia allowed herself to bring up a topic that was both sensitive and of great concern to her.

"The only serious talk we ever had was one time when we were sharing a taxi home after an out-of-town shoot," Charlton says. "At that point, I'd heard she was shooting heroin. [A lot of people] did coke—cocaine was common, but heroin was not. She asked me what I thought about that, and I remember saying

'If you tried it once, that's OK, but don't keep on going. Don't keep on going.' She wanted me to say, 'It's OK,' to make her feel better, but I'm not a counsellor, and I remember trying to say to her 'It's *not* OK' in that taxi ride. I [thought she] felt safe with me, but she didn't go into any details about what she was going through. That would have been a perfect time for her to open up, but she didn't. So I don't think of her as someone who would tell everyone her problems."

"We were all exposed to that stuff," says Christiaan Houtenbos. "Some reacted differently. What her particular cross was, I couldn't tell you. I'm sure [it was] quite depressing to find out that you're one of the girls who [caught] a disease that was supposedly only for gay guys. Why one girl goes over the edge and another girl doesn't is complicated.... All I know is that we had a great time with her. I can't possibly say a bad word about her. It is a weird, easy, but stressful business. Always being passed around and shoved [here and there] in situations where, whether you feel like it or not, you have to rise to the occasion.... Sometimes, it's impossible to save somebody. I know my wife Marianne certainly made a valiant effort to keep Gia from going over the cliff, booking her when she was down and nobody wanted her, just hoping to pull her back into a sense of normality. But you lose at some point, and you have to give up and move on."

For Suzanne Rodier, "the only thing that could have helped Gia was going into detox earlier. It's a disease. No one can start you on a drug and no one can stop you from doing it. It is beyond human help. It has nothing to do with willpower or intelligence.... She called me once from rehab and said she had nowhere to live, so she came to live with me. And that was the first time I ever knew anything about the drug abuse. I knew nothing about addiction then. I just gave her a place to live and within two weeks she was gone from my apartment. She [stole] things to sell, and I never held that against her because I knew she was desperate.

"If someone from AA had gotten a hold of her, and she [had] found a kinship with someone, that may have helped. But she

was always looking to fill an infinite void with finite things. And that never works. Everyone who knew Gia, we all thought, 'If only we had said this, if only we had done that.' We've all beaten ourselves up, I'm sure. I know I did. Everyone. Because after the fact, everyone thinks, 'I could have saved her.'" Still, continues Rodier firmly, "I've seen people of all walks of life in the same predicament. It doesn't matter how educated they are, how cultured. That has nothing to do with it.

"She was just gorgeous. I believe she was the first brunette, brown-eyed woman to grace the cover of *Vogue*. She was so gorgeous that she [could get to that level] immediately. She had an almost animal attraction. She was full of spirit, and she really did have a zest for life. I know they're not responsible, but I think it's sad that the industry allowed her to work and work and work until the bitter end."

26

KIMBERLY

Kimberly Lloyd (not her real name) was neither a model nor a famous singer, but everyone in Atlantic City knew her. Lloyd wasn't the kind of woman to spend her evenings at home on the sofa watching rom-coms on TV. She was a party girl, and she loved having a good time. Lively and quick-witted, her sunny nature matched by the color of her bright blonde hair, Kimberly Lloyd was Gia's girlfriend until nearly the very end. The destinies of the two young women were so inextricable entwined, in fact, that they shared the disease that ultimately killed them both. Once Gia was gone, Lloyd tried to move on with her life, but the deep love she had experienced for her "boy," as she often affectionately referred to Gia, never faded. In the background of her everyday life—which she filled with hopes and plans—Gia was there in the form of memories. All those memories—perhaps too many to bear—came flooding forward when Lloyd looked at the old photographs that decorated the walls of her apartment. Gia was still alive in those photos—and in Lloyd's heart.

Barbara Paladino recalls meeting Lloyd in Atlantic City, where Lloyd worked as a manicurist at a local salon. "The best salon in the neighborhood," Paladino recounts. "She used to manicure

my nails. That's how I met her." The two bonded instantly, and Paladino's memories of their friendship remain special. "We partied a lot together. We went to clubs, and we did a lot of running around Atlantic City. We used to go to New York together. She was a party girl, basically. She knew a lot of people. Kimberly was very pushy sometimes, very influential. She helped get me my job in the casinos when I first moved here. She was very well liked, and she knew a lot of people in the area. She was very social.

"I could tell you a lot of cute things about Kim," Paladino continues. "She loved Mick Jagger and the Rolling Stones. That was her thing. That's one of the things I remember about Kimberly the most. And she did Mick Jagger impersonations, all the time. She was very trendy, very outgoing. She was always up for a party, always up for fun. We spent a lot of time together. She was a very good friend."

Paladino also recalls how deeply connected Lloyd remained to her former girlfriend in the years after Gia's death. "When I met Kim, Gia had already passed," Paladino says. "Kimberly lived in a high-rise apartment, a beautiful studio apartment right on the beach. She had pictures of Gia all over, and she was head over heels! She would show me pictures, and it seemed like they were inseparable. Kim always wanted Gia to wear white blouses and blue jeans. When I met her, she used to say to me, 'You remind me of Gia. You look like Gia. You have [her] dark hair. You should wear this, you should wear that.'"

It's easy to imagine Lloyd staring out over the ocean from her marvelous apartment, lost in nostalgia as the movement of the waves brought back feelings that had never dimmed. During the time that Paladino knew her, Lloyd met a new girlfriend and, Paladino recalls, "she even made her new girlfriend dye her hair black and wear white blouses and blue jeans." In telling Paladino about her relationship with Gia, Lloyd had used one adjective: passionate. "That's how she described her love affair with Gia—a passionate love," Paladino says. "Actually, Kim was very passionate, too. When she wanted something, boy, she went for it!

"Kim used to say Gia was very aggressive. They used to go to Atlantic City a lot and party, and she said Gia started to get into drugs really bad. Other than that, she used to call Gia her boy, her little boy. She used to say that Gia just wanted to be loved, to have someone there for her all the time. And Kimberly was that person. Kimberly would have been that person for anybody she was friendly with, myself included."

For Paladino, Gia's attraction for Kimberly was obvious. "First of all, [Lloyd] was a cute little blonde and she had a little bit of a tomboy side to her. She was very protective. If you were her friend, nobody could hurt you, nobody. She was very strong. I think people are drawn to that. She would do anything for you. If anyone did something to me, she would tell them right to their face, 'You're a piece of shit. You can't hurt Barbara.'"

There is one deeply painful memory among Paladino's collection of pleasant ones, however. "I remember the day Kimberly told me [she had been diagnosed with] AIDS," Paladino sighs. "I remember that day so well, She was doing my nails ... it was horrible." It was one of the last days Lloyd spent in Atlantic City, in fact. "Her family took her home and they made her live upstairs in an attic. They were ashamed. That was hard, that part."

The unfairness of her fate notwithstanding, Lloyd wasn't abandoned by her friends or her girlfriend, who visited her as often as possible. Paladino recalls that "four or five [of us] would drive up and visit her. And her girlfriend, who stayed down here, would go up every weekend." Paladino says she never knew anything about Gia's and Lloyd's drug use, "but it wouldn't surprise me. I think they both used a lot of drugs. Unfortunately, that's [also] how Kimberly died. I believe they shared IV needles."

The Philadelphia-born photographer, Sam Scott Schiavo, concurs. "It was very common then to share needles," he says. "Almost like a form of shared friendship. And in those days, it was always unprotected sex. I went to Italy in June 1984 and, in the months before, friends were starting to talk about friends who had died after a week of pneumonia."

Kimberly Lloyd was also apparently the type of woman who liked to mark her territory, an aspect of Lloyd's personality that Paladino alludes to when she recalls Kim as "very controlling. She took care of her partners." Hairstylist Anthony De May was an unwilling witness to Lloyd's jealousy. "I met Kimberly once the year before Gia died," De May recalls. "Gia was living in Atlantic City, and I had a summer rental up the New Jersey shore on Long Beach Island. We would drive down to Atlantic City about midnight on Saturdays and go to the gay clubs scattered along New York Avenue. [One night], I noticed Gia there, who at that point, had cut her hair into a short mullet. She was wearing old jeans and a man's white shirt, and she was dancing [by herself] in her own world, and I thought to myself, I wonder if anyone realizes that Gia, supermodel of the world, is here, just blending in? So I stepped onto the raised dance floor and shimmied over to Gia. She had that sort of shocked-slash-bemused reaction of seeing a familiar face in [an unexpected] place. We started to dance together—getting close, but not sexual. I realized she was really high. She wasn't even going to attempt to talk, but she was communicating through her eyes. I knew Gia, so I wasn't going to ruin her buzz. Suddenly, the girlfriend [Lloyd] comes up to us and pushes me away as if I was trying to flirt with her. The last thing I wanted was to get roughed up by a girl, so I left the dance floor, feeling a quiet rage, and that was the last time I saw Gia alive."

By chance, Schiavo had also met Lloyd in a New York Avenue club in Atlantic City. It was in the summer of 1978—years before De May's encounter. "At the time, Kim was also a pretty blond girl," Schiavo recalls. "She was a cute girl, all smiles. She had a good personality. I think she was hanging out at the Chester [an Atlantic City club that was the rage among both gay folks and hip, discriminating heterosexuals] with a group of friends of mine from Philly." Lloyd was known for being in the company of pretty young women, and Schiavo remembers one in particular, "a beautiful girl named Julianne [not her real name]. Julianne was

straight, but I think now and then she had something with Kimberly. These girls were far from typical lesbian girls. They were all attractive, sexy. It was the age of disco."

In the early eighties, Gia was also known to frequent a popular nightclub in Philadelphia, the Second Story. "It was the most famous [club, known for] crazy, crazy nights," recalls Frankie Sestito, an internationally celebrated DJ. "It was open for twelve years." Schiavo, too, saw Gia there—in the company of her latest "beauty," a woman who was not, at the time, Kimberly Lloyd.

Schiavo recalls meeting Gia through Marine [not her real name], another of Gia's lovers. "Marine was a beautiful hairdresser from Philly," Schiavo says. "They looked beautiful together. Gia didn't wear makeup; Marine did. Marine was a regular [at the Second Story] for years. I think Gia only came in a few times with her. She was still looking good then, always happy, always dressed in a man's white undershirt and jeans. I remember a Halloween Party at the club when they came together. I was dressed as a pregnant Catholic high school girl. I joked with Gia that she could be my baby's godfather!" The photographer's habit of writing the dates on the back of his photos proved useful in helping Schiavo pinpoint the date: "She was with Marine in the autumn of 1983."

Despite Gia's brief fling with Marine, Gia and Kim's love affair continued. Because of Gia's and Kim's shared drug use, some have attempted to diminish their bond by labeling it a "chemical romance." But Rob Fay couldn't disagree more, and his recollections are fundamental to setting the record straight—especially because he reports Gia's own words on the matter. "Contrary to whatever anybody else seems to think," Fay says, "Kimberly was *the* love of Gia's life. Gia told me that. I met Kim a couple of times, and they were just as close as you can imagine." In Fay's own experience, moreover, he "got a very good vibe from [Lloyd]. She was very womanly, very friendly. They cared about each other."

27

YOU CAN STAY

Reflecting on the role of the fashion industry in Gia's decline, Borodulin is typically plain-spoken. "*C'est la vie*," he says. "You can blame [agents or others in the business] or you can blame her. The way the fashion business works, which is like the way most businesses work, it isn't for mothers and their kids. It's not a family-type activity. There are no psychiatrists in modeling agencies—there aren't now and there never have been. Instead, there are bookers, fashion directors, and people doing other kinds of jobs, and they're dealing with fifty models at the same time. Gia probably could have used a maid, or a mother, or a shrink, or a boyfriend—in any case, someone who could have given her some direction. That would have been good for her, assuming she'd have allowed it. Maybe she wouldn't have, though, because she was someone who liked to take care of herself. She wasn't interested in having other people tell her what to do."

It's tempting to speculate about what life might have been like for Gia if she'd actually had a parent present during her first years in New York, and whether that might have helped her avoid the "temptations" that proved so dangerous in the long term. Borodulin doesn't think so. "Just imagine Gia's mother telling her ...

that she shouldn't go to Studio 54, which is where we went every single night," he says. "And imagine Gia saying, 'Yes, mom. I'm going straight to bed.' Imagine having a child and telling her, 'Don't go there, don't do this, don't do that.' But your child is a celebrity while you are not. That makes things even harder. Gia loved her mother, but she never talked about her. In fact, she never talked about either of her parents, but I think she loved them both. Once I went to Gia's house [in Philadelphia], and I met her mother. I was amazed how close the two of them were. I had no idea."

With regard to the strength of that mother-daughter bond, Rodier had no reason for doubt. "Gia wanted her mother around, and [when] her mother [was] around, she would want her to go home," Rodier laughs. "And as soon as she left, Gia would want her to be around again. They had a strange relationship. But even at the end, when Gia was sick, her mother wanted to go to the gynecologist's office with her. They had a strong bond, no matter what was beneath the surface. They needed each other in some ways. What a life."

According to Rodier, Gia was no less attached to her father. "She loved her dad, and he just adored her. I heard he died maybe a year after Gia, but I'm sure his life was never the same. That was his girl. She used to shoot pool a lot at her father's when he had the hoagie shop. They lived up above, and they had a pool table. So she would shoot pool with her brothers and her dad. She was an excellent pool player. But they adored each other."

Recalling his last, emotional meeting with Gia, Borodulin says that Gia "called me in New York. I don't remember what she told me, but afterwards she came up to New York to see me.... When I looked at her, I couldn't believe my eyes. She was a completely different person. Her eyes looked dead. She was no longer radiant or beautiful. And yet, even though she had changed, she still had what it took to be a supermodel. I thought she needed help. Somehow or other, I still loved her, and I had this sort of idealistic fantasy that I could help her. At the time, a lot of peo-

ple wanted to help. Now I know there's no real helping people who use drugs. They need medical care. They need some sort of revolution in the way they live their own lives so they can become their own doctors. It's happened to a lot of people I know. It's just that I'm a good person, and when I see friends who are falling apart, I try to help. But I realized I wasn't strong enough to do that. If they're falling apart and you want to help, you're going to end up falling apart, too. It takes every single thing you have to give and more to keep that person from slipping.

"I wasn't thinking [the worst], but she wasn't in good shape [during that last visit]. She did look better than she had when she got out of rehab. Still, something wasn't right in her. She seemed off-balance and, like so many times before, I didn't know what to do. That last time I saw her, I was struggling financially, trying to survive, and I couldn't have taken care of her, but I told her, "If you need a place to stay, come here. You can stay." So she slept at my place that night and, in the morning, she disappeared. She was gone when I woke up, and I never saw her again.... I even have a photo of her that I call "Gia's Last Photograph."

When Borodulin heard the news of Gia's death, "I was sad," he says. "She was an important part of my life, and I think about her quite often. On the one hand, I'm glad to have survived [those years]. I could easily have died—there would have been nothing to it—because the two of us were very, very similar. What happened to her could have happened to me. The only thing that stopped me was that my life was, so to speak, richer than hers. She hadn't had a good education, but she was maybe better than me in terms of functioning in the world because she had more ability to understand things. When you read a lot [as I do], you live a variety of lives. Each book is the life of a different person and, if the book is a good one, you can experience the consciousness of all those other lives. That was something she didn't have that I did. That awareness and the love I experienced for my art are what kept me alive. She didn't have that to hang onto, but we were practically identical."

28

AN ANGEL NAMED ROB

By the time she met an "angel" named Rob Fay, Gia seemed to have been through the mill. He was the friend she had needed for so long. She met Fay in a place where glamor wasn't even a distant memory: the drug rehab program at the Eagleville Hospital in southeast Pennsylvania. At Eagleville, even the walls seemed to tell stories of sorrow, of tormented and often lonely souls who had tried to ease their pain with alcohol or, like, Gia, had stuffed themselves full of drugs in the hope of dulling negative emotions and smoothing over inner conflicts.

Eagleville was Gia's last hope. She had to free herself from the diabolical mechanism that was holding her a prisoner in her own life, and she needed to do it urgently. If she wanted to succeed, she had to get back in the driver's seat of her destiny. That was the only way she could follow her dream, not such an impossible one at that, of becoming a cinematographer, something Gia herself had mentioned in a video she recorded in Atlantic City, in the studio of her dear friend, the late Jeffrey "Jeff" Sleppin (Sleppin was also a fashion photographer often employed by Ford Models).

Rehab was no stroll in the park. After their morning meetings

and respective therapy groups, the patients had rec time. As Fay recalls, "After the day was done, we'd go into the gymnasium. We'd play ping pong, volleyball...." In those moments of distraction and relaxation, Fay and Gia began to open up to one another. One of the first things Fay discovered was what Gia had done for a living. "Let me tell you how I discovered exactly what kind of model Gia was," Fay says. "When I first met her, she told me she'd been a model. That didn't impress me all that much because I had worked as a model a couple of times, but I didn't reach [Gia's] level."

At one point, Gia and Fay decided to go to Gia's mother's house in Richboro, about thirty miles east of Eagleville. Gia didn't have a key, and the two were forced to break in (later, Gia's mother would tell Fay she was "OK" with the break-in). "When I got into the living room," Fay recalls, "I saw the *Vogue* and *Cosmo* covers on the walls. That's when I realized how much of a model she was. [When we] went upstairs to her room, she showed me a bunch of pictures. It was pretty cool, but she never really expanded on the whole experience. [She talked about the] parties, but nothing real serious. We had both lived a life that was full of occasions and excesses, and it wasn't exciting to me. I was more excited about my new life, being sober and trying to live the principles and values we were adopting in recovery. I'd been reborn. We had the wreckage of the past, but we were working on that. It was a new exciting life.... We talked a lot about things that mattered—not money and stuff like that—but about helping other people and trying to get the best out of every day. She was generous in every way. She never really had any money, so that didn't matter. We were just gonna survive.

"She was lovely and fun, and she cared a lot about people. She wanted to laugh and joke, make people smile. And we did a lot of that. But I wouldn't say she was frail or timid. When she wanted something, she went after it. She was never looking for a fight, but she stood up for herself, and that was a good thing. As a drug addict, of course, she had a lot of troubles. Troubles just seem to

follow drug addicts. They do amazing things to get high. I think the disease of addiction is a brutal thing. The real problem wasn't the drug or the alcohol—the real problem was a lack of power. The disease completely destroyed her life."

Gia confided in Fay, telling him how she really felt about the fashion industry. "Gia wasn't impressed by [modeling]. She knew it was bullshit, that it was a phony lifestyle. I imagine she probably had regrets that she burnt herself out too fast—because she did have a lot of plans for her life. She wanted to work with kids. She wanted to have kids. I can only imagine what [would have happened] if she hadn't died.... She wanted to make movies, and we talked about making a little film so she could help kids stay away from her lifestyle."

While Gia was at the height of her success, the line of people who wanted to share her company seemed endless, but when the first inklings of her drug problem began to circulate, that list shrank drastically. Even after her death, the number of individuals who claimed to have been her friends continued to grow, the natural consequence when a legend is consecrated by death. That fact is of no small annoyance to those who actually spent years by Gia's side, from her beginnings to the point at which she began to descend into her Stygian autumn, a landscape where fallen leaves gathered in frigid, melancholy drifts.

But summer, not autumn, had always Gia's favorite season of the year—in part, Suzanne Rodier recalls, because "of all the girls in T-shirts." That last summer of her life, though, was different. The light-hearted spirit of summer had given way to a storm of conflicting moods. In its wake, hope and certainty were swept into useless tangles. Gia had only her own reserves to call upon; she could no longer count on the few real friends she'd encountered in the course of her glamourous career.

Fay recalls that "the only one who visited her at Eagleville—other than her mother—was Joe Petrellis. I would say only Joe [was a truly loyal friend]. He came to visit Gia at Eagleville, and I was the only person Gia introduced him to.... Scavullo [the pho-

tographer] tried to make contact..... She called a lot of people in New York, and nobody returned a single call. I know this because she used my phone to do it, and I know it broke her heart because nobody was there for her," Fay sighs. "It was really painful to watch.... A lot of people claim [to have wanted to contact her], but in that summer of 1986, when I held Gia in my arms, she was crying because none of her New York friends had called her back. Sometimes I get upset about that. Sometimes it's very painful because it reminds me of the pain Gia went through. All I can say to those people who claim to have been a part of her life and to have cared about her is: Where were you in the summer of 1986?"

That fateful summer may well have been a litmus test for those whose affection for Gia was genuine. At the same time, it is true that a series of unforeseeable events took place in those months that deprived Gia of some of the people who had proven themselves most loyal and dependable. By 1986, for example, several friends had left both the fashion business and New York behind for good. Some had moved to other continents, some had begun new careers, and still others had gotten married and moved away to raise children. A few had been forced to abandon successful careers, temporarily or not, in order to care for parents who were ill or dying. Those who remained in the Big Apple went on working at a breakneck pace: the business wasn't about to wait for anyone. It wasn't all that strange, then, if even good friends didn't hear from one another for weeks or months at a time.

For those who had stood by Gia's side through thick and thin, however, and who were with her during the worst of her final days, such excuses have the ring of falseness. They're too easy, too convenient, and too ready-made for covering up lapses that cannot be justified. In more than a few cases, those weeks and months became seasons and then turned into years. Gia lost many chances to say goodbye. And yet, had she or hadn't she been one of the most admired and the most requested (even pursued) female supermodels at the end of the seventies, as Borod-

ulin says? A Bantu proverb tells us that friendship is like a trail in the sand. If it is not renewed constantly, it disappears. The fickle currents of time and tide left only the barest of traces.

There can be no doubt that Gia's drug addiction was a negative influence on her ability to maintain friendships and romantic relationships. "As a drug addict, you can't be friends with anybody," says Fay "When you're a drug addict, your only friend is the drug. There are no stable relationships in a junkie's life. When you get sober, you can't hang around the same people, and sometimes it becomes a life-or-death decision."

Gia's relationship with Kimberly, of course, couldn't continue unless both of them got on the right path. "They both had the disease of the addiction, and that can be a brutal thing, especially between two people," Fay adds. "I know how Gia felt about [her relationship with Kimberly], and I knew that Gia knew it was the end of the relationship unless Kim was going to get clean, too. [Even if she had], it would have taken a long time for them to repair the damage they had done."

One person with whom Gia never lost touch, no matter what, was Suzanne Rodier. Their friendship was stronger than the physical distance or time difference that separated them. When, at the beginning of the eighties, Rodier moved to Tokyo for more than two years, their strong bond never wavered. When Rodier returned to the U.S. in early 1983, the two reconnected. Subsequently, Rodier recalls, "I moved to Philadelphia to take care of my mother, who was dying of cancer. I used to talk with Gia on the phone, and she would say, 'Oh, have you tried holistic?' and what not, but she never told me she had AIDS."

On one occasion, after Gia had been in rehab in Pennsylvania, she visited Rodier in Philadelphia. Only a few months had passed since Rodier's mother had died. "I answered the door, and she wasn't the Gia I remembered," Rodier says. "She was still gorgeous, but the color was gone from her hair. It was starting to fade and look dull. She had always had that rich, glossy, brunette hair. Her skin was dry with little tiny bumps [even though] she

had always had perfect skin. And she was moving slow. I wanted to kill her for this, [but] she never told me she had AIDS. After she died, I was so disappointed that she didn't trust me enough, but that day we talked for hours and hours. We spoke about the Bible." And there was something else they discussed: "She still always wanted to get back into the business."

Rodier's memories of Gia also extend to "how much she used to love to wrestle. That was our thing. We would wrestle. When we lived together, we would put a blanket down on the floor, and we would wrestle. That was our pastime, our playtime in New York. We never did it in Philadelphia. [But] the last time I saw her, when she came to my house in Philadelphia ... we spoke for hours, and she kept saying, 'When are we gonna wrestle again?' She didn't tell me she was sick, but I knew something was wrong. She was weak. She was taking pills every four hours. I wasn't aware of AZT at that time, but we talked about everything. Every twenty minutes she would stop and look me [right in the] face and say, 'When are we gonna wrestle again?' She looked like a little girl when she said that.

"She was always trying to make people laugh. She was always the one trying to make you smile, and she was very generous about that. She was an amazing human being. She was extremely sensitive to the world. She was self-centered, but I think all of us are. I don't know how to say it kindly. She was self centered the way the rest of us are, but especially when she was in her [addiction]. Which is understandable: Everything is self-seeking and selfish ... but I never held anything against her.

"Still, I can't really think about Gia. Even if I try I can't, so I don't even try. For me, the past is the past. It was sad enough when it happened, so after this interview, I'm not going to talk about her for a long time."

And yet Rodier concludes with memories of happy moments she spent with Gia, almost a sort of mental slide show. "I think we wrestled because we were both happy and giggly," she says. "That was my favorite time." (Unfortunately, Rodier laughs, no

pictures exist of those matches.) Another snapshot of her time with Gia that remains among Rodier's most cherished memories is "the first day I met her, when she slid into my car. It was amazing." Like a pair of adolescents in love, Rodier and Gia also spent time at a "place in Philadelphia called The Pines [a forested area outside the city]. That's where people went to park and do whatever they were going to do. She and I used to go there a lot. We just had a great time. We would fool around and walk in the pines and smell [the sap], and talk about life and the future. Those are great memories."

29

BRAVE GIRL

The long period of hedonism that began in the 1960s was about to come to the worst end imaginable. The Grim Reaper had begun dancing through the streets of New York City, looking directly into the faces of the happy, carefree passersby, reading their deepest desires: to fall in love, raise a family, find success in their chosen careers, and so many other dreams. But the voiceless Reaper never softened. He had his own plans to attend to. At the beginning of the eighties, he began to bring them to fruition with the help of a new accomplice: the deadly human immunodeficiency *virus,* HIV.

Gia was always brave, but the true dimensions of her courage were even more evident as she dealt with the terrible illness. By the middle of the 1980s, anti-HIV treatments were still unable to prolong patients' lives in any significant way, and they and their families had a dual drama to contend with: the disease itself, first of all, and then the fear that came from realizing that doctors knew almost nothing about HIV or AIDS. In their shame and embarrassment, moreover, the families of people with AIDS sometimes kept patients confined at home, away from the public eye. The often-conflicting treatment recommendations for HIV

and AIDS were in agreement on one point, however: the virus was deadly, and there was no cure.

Rob Fay, who continued to spend time with Gia after her final stint in rehab, says she was fully aware that her life was drawing to a close. Gia's lucidity regarding the fate that lay before her might lead us to imagine she was filled with desperation, devoid of hope. But that was not the case. Gia never gave up on life or on her dreams; she never stopped being herself, just as she had always done—one of the aspects of her character that had made her a star. She renewed her religious faith because, in those moments when we are tested, we can avoid the abyss only by seeking answers to the questions that every self-aware human being asks. We take stock of our lives, of what we've done—and what we've failed to do. In the midst of illness, some individuals evolve into new selves. Gia left behind her days of partying and the social whirl—all of that seemed light years away! She knew what was important now: no longer the materialist mantra "time is money," but rather "time is life." As long as her strength held out, Gia refused to lock herself up in the house. She spent time with Rob Fay and Joe Petrellis, and she saw Suzanne Rodier for the last time. She used the days that remained to reflect, perhaps in a way she'd never had a chance to do before. It was almost as if she'd been touched by grace, finally able to distinguish clearly between what truly counted and what was superficial, dispensable, irrelevant to her existence. Gia's strongest desire was to leave a mark on this life.

During Gia's final illness, Rob Fay recalls that she "had incredible mental strength and an incredible faith in God. She knew [life] was difficult, especially for people with AIDS. She knew God had a plan for her.... She knew she'd be able to help people, and that's exactly what she did. She wanted to help whoever she could reach—those young girls who thought all that crap in the magazines was real life. She wanted everybody else to feel the pain she'd been through."

The grains of sand continued to descend inexorably through

the hourglass of Gia's life. It was October. Gia had little time left to her, but she used that time as best she could. She focused on what she could do to help others, including those who were dealing, as she had done, with the hell of drug addiction. She made plans for a video about how she had come to recognize the damage her heroin addiction had caused. Her physical state continued to deteriorate, but she communicated with her friend, Rob, until the point where her mind was no longer clear. The final thoughts she left him with are essentially hopeful ones: It is possible to escape from addiction. Better still is never to get involved with drugs in the first place. They don't make life better, and they don't solve problems the way many young people (though not only the young) hope they will. Gia entered a dark place filled with overwhelming anxiety, plummeting quickly toward the inevitable. She died on November 18, 1986, leaving a space that could not be filled in the hearts of her family members and of the few genuine friends who had stayed with her.

Eva Voorhees who had, in the meantime, returned home to California, recalls that "one day, on my way to the gym, somebody just told me [about Gia's death]. Just out of the blue, [one of those] matter-of-fact things. I cried my eyes out for hours upon hours upon hours. It was raining that day, and I remember walking along the bike path on the Santa Monica beach and just crying and crying and thinking about her life. It was really a bad day."

After Gia's death, Juli Foster reached out to Gia's mother, Kathleen. "I spoke to her a couple times a month for a long time," Foster recalls. "I tried to help, but there was nothing I could do. She had lost her baby!"

Perhaps it is Patty Sicular who deserves the final word in this journey through the brief, passionate life of Gia Carangi. "If Gia were alive today, do you think she'd be happy being middle-aged?" Sicular asks. "What do you think would have become of her? I don't think she liked modeling. I think she might have liked many things, working at a sandwich shop maybe, or some other place. I think she would have been happy doing that. Having loved ones

and friends to surround her. I think she would have been happy working in the family business and raising a family of her own. I don't know if I mean children, but being married or being with someone [she loved].... Without all the pressure, I think she would have enjoyed the friendships she found along the way."

Beyond all the fantasies projected on to her, in other words, beyond the dreams others presumed she wanted to fulfill, the extraordinary Gia wished for one thing more than any other: to live a normal life.

Made in the USA
Monee, IL
29 July 2021